IMAGES
of America

AFRICAN AMERICANS
IN RUTHERFORD COUNTY

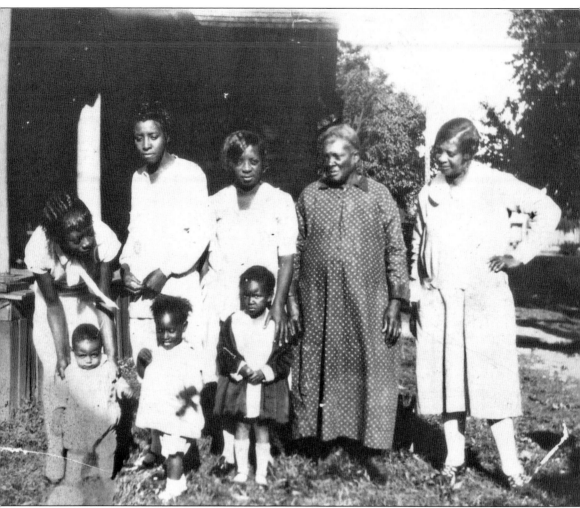

This photograph of former slave America Eules and three generations of her family was taken outside of their home on Sevier Street. Shown here with Eules are, from left to right, (first row) Calvin Johnson Jr., Christine Watkins, and a young Ernestine Burris; (second row) Mariah Hayes Douglas, her granddaughter; Lucy Brown, a neighbor; America Douglas, her granddaughter; Eules; and Dora Douglas, her daughter. On Eules's 100th birthday, the former Key United Methodist Church member reminisced about the church's beginnings in the local newspaper, noting the various preachers and church meeting places, including the "brush arbors" that served as a church location until the formation of the church. The original article, held by neighbor Ernestine Burris Tucker, shares Eules's story of walking behind her mistress's buggy as they traveled to Asbury Methodist Church on Mason Road and her memories of worshipping downstairs with the other slaves while the slave owners worshipped upstairs. America and her husband, James Eules, are both buried in Benevolent Cemetery in Murfreesboro. (Courtesy of Ernestine Tucker.)

ON THE COVER: A proud and beaming Stella Butler (far left), daughter of Mattie and William Butler, graduates from Bradley Nursery School kindergarten. Other class members from left to right include Neal Black, Diane Kersey, Bessie Woods, Horace Butler, and Carolyn Cason. This photograph is identified as taken in front of the house of educator Lillian Hammons, the class teacher. Hammons was the school's founder and served as its director for over 70 years. (Courtesy of Mattie Butler.)

IMAGES
of America

AFRICAN AMERICANS
IN RUTHERFORD COUNTY

Devora E. Butler

ARCADIA
PUBLISHING

Published by Arcadia Publishing
Charleston SC, Chicago IL, Portsmouth NH, San Francisco CA

Printed in the United States of America

Library of Congress Control Number: 2009927289

For all general information contact Arcadia Publishing at:
Telephone 843-853-2070
Fax 843-853-0044
E-mail sales@arcadiapublishing.com
For customer service and orders:
Toll-Free 1-888-313-2665

Visit us on the Internet at www.arcadiapublishing.com

To all of the so called "ordinary," seemingly obscure African American citizens of Rutherford County and to my husband, Bill, and our three girls, Alyss, Augusta, and Anniebelle—much love to you all.

CONTENTS

ACKNOWLEDGMENTS

African Americans have contributed to and helped to shape the unique and vibrant area of Middle Tennessee known as Rutherford County for many years. Men and women have lived, worked, and toiled for generations, working in their lodges, clubs, churches, social groups, and professions to keep the spirit of the community vibrant and growing. These ordinary individuals are truly heroes and heroines in my eyes. I thank the many people who shared their stories, tales, and photographs, as well as those who shared their private collections and archives to make this work possible. I hope that this compilation adds breadth and depth to the area's history and culture and will serve to provide a more complete picture of this area we call home.

I thank Ernestine Burrus Tucker, a friend to my late mother, Dolores Williams Butler, and an invaluable resource for me. She has been honored before, upon her returning from afar; however, in my eyes, it was not enough. It takes love and compassion for an area to preserve information like she does, and I will be forever grateful to have had the privilege of her time and conversations. To my father, James L. Butler Sr., who has a life that reads like a novel and a pretty good memory to go along with it, I say thank you. My parents took the time to share their stories and tales, music, dances, and their sagas of an era past, which led to my appreciation of history.

INTRODUCTION

My historical interest in my birthplace was piqued after gathering information on my family's history in the area. After spending 10 years of work and study in Seattle, Washington, and graduate study in education at the University of London in London, England, I returned to Rutherford County. Upon my return, I began inquiring as to what people did in life, how they lived, and where they went to school.

Residents shared with me amazing stories of educators, doctors, soldiers, ministers, and businesspeople who contributed to the African American community of the area. The exciting stories I had heard while growing up and the individuals I knew all seemed larger than life, proven evidence of the area's thriving and lively past. I wanted to know more, as if I were connecting a puzzle; I began looking for the people I knew growing up and inquiring about the "Mink Slide" and "the end," while recalling my personal experiences of "gypsy breakfasts" and "basket dinners." These people with incredible courage and unbelievable dignity managed to live, love, and laugh and make a home in the area amid a backdrop of "Jim Crow," "separate and unequal," and the horror of two documented lynchings of African Americans in the county.

As with the history of most of America's African American communities, the church has been its center and its backbone. Thus is the case with the African American community of the city of Murfreesboro, the largest in Rutherford County post-emancipation. By 1870, the four African American congregations founded in Murfreesboro were precursors to the present-day Key United Methodist Church, Allen Chapel African Methodist Episcopal Church, Mount Zion Baptist Church, and First Baptist Church. Through these churches and their efforts came many area African American schools as well. In an old newspaper article, Rutherford County native America Eules spoke of her life in servitude and of following her mistress's buggy to church and worshipping with other slaves in a Methodist church basement while the owners worshipped upstairs. Newspaper interviews near the end of her long life indicated that early Key Church assemblies were held in brush arbors. The personal stories of America Eules and another local ex-slave, Berry Wesley Seward, come to mind when I study the history of the African American church in Rutherford County. Both local folk coming from a hard life of bondage and toil, they held tight to their belief that their God would lead them to a better life. These folks put that strong belief into practice as they helped to build a church and a community that would support them and their offspring for successive generations.

These folks helped to create me, for I am a product of Key Church. I was christened there, baptized, Sunday "schooled," Christmas "played," Easter "speeched," a lifetime member of the United Methodist Women there, Vacation Bible School taught, Black History Month informed, and even held a wedding in its chapel. The church sent me on a United Nations and Washington, D.C., study tour that politicized me for life. I have personally experienced the power of a strong church and its ripple effect on the people of a community and vice versa. When one discovers Rutherford County residents that exemplify such endurance and strength, we know the substance on which the foundation of our African American community was built. This foundation was built on faith and unity, solid ideals from which any American can spring. I hope to convey the character and strength as well as the backdrop of the white Southern construct that was in place as these accomplishments were made.

I have divided this work into three main headings: Education, the Military, and Faces and Places of Rutherford County. The "Education" chapter was developed because of its extreme importance to the emancipated slave, for through it freed men and women would be able to comprehend their

constitutional and civil rights and better themselves in life, thus leading to greater progress for the African American community. I would like to convey the great spirit of camaraderie and the dedication of a generation of educators instructing as well as those who attended the schools.

As an educator, I was captivated by the value placed on education in eras past, thus the chapter regarding education. I read of teachers such as William "Sneak" Butler and how he solved the problem of low enrollment at Squirrel Hill during cotton picking time, and how at Gladeview School the stove fire had be started early to heat up the one-room schoolhouse before the students came. Antioch School and Sulphur Springs School were attended by 98-year-old resident Dora Rucker. She remembers walking for miles to school as a student in good and bad weather, and if one was fortunate, one had a buggy on those wet, muddy days. When she got to Antioch School, she would see her classmate and dear friend Willa Kimbro Foster, a joyful memory for her even today. James "Link" Butler Sr., as a student, recalls catching a car or a wagon for a ride from Woodbury Road to old Bradley Academy in town. He would also describe how he would use his father's wagon and horse at times, parking it in the back of his uncle Spain's house on Academy Street until time to go home.

The chapter regarding the military inspires deep pride within me. Rutherford County boasts African American soldiers who fought in the Revolutionary War, Civil War, the Spanish-American War, and World Wars I and II, as well as the more recent wars and conflicts. Tennessee, having coined the nickname the "Volunteer State," has been shown to have no shortage of African American patriots stepping up to their country's defense. Soldiers of Rutherford County volunteered and were drafted, like many other Americans, to serve and defend their democracy. Peter Jennings, the Revolutionary War veteran and pensioner who settled in this area, is to be noted, as well as Sampson Keeble, a former slave from the H. P. Keeble Plantation in Rutherford County, who moved to Davidson County and was the first African American to be elected to the Tennessee General Assembly. He apparently was also a Confederate War veteran as well. Benevolent Cemetery is a historic, local African American cemetery in town that boasts graves of veterans and other non-military citizen heroes and heroines of Rutherford County, even those from the Spanish-American War. The cemetery is a source of pride not only from a historical standpoint, but as the burial place of many of our area's loved ones.

The "Faces and Places of Rutherford County" chapter showcases how many extraordinary people helped to give the area its strong backbone that helped build the area's prominence in the state and nation and internationally. Extraordinary individuals worked and toiled to ensure a rich and thriving local culture from which we still benefit today. The area boasted midwives, trained nurses, medical doctors, athletes, numerous educational doctorates, an attorney, and businessmen and women who have left their indelible mark on Rutherford County. However, the segregated local area did not allow the equal treatment of African American citizens. Thus, they were able to clean, wash, cook, and labor to build the greater community but not get full benefits of its fruit. For example, although there was a higher education institution in town, African American professionals went on to Nashville, Tennessee, to Fisk University, Tennessee Agricultural and Industrial, and other Historically Black Colleges and Universities in the region, or up North, to obtain a sound education to progress themselves and "their race." Area locals served as maids, chauffeurs, janitors, cooks, gardeners, and nannies to the white community in order to earn a living and support their families. In a much larger sense, they helped to build the thriving, nationally recognized, 21st-century area we enjoy today.

These are just a sampling of the many African American people who through their local laboring and service throughout the years, in Murfreesboro and Rutherford County, helped to contribute to this great place that many of us call home. May we learn from the past to enable an even better future for us all. I look forward to seeing the area celebrate its continued positive growth for the benefit of all people of the local area, the state, this great country, and this world that we all call home.

One

EDUCATION

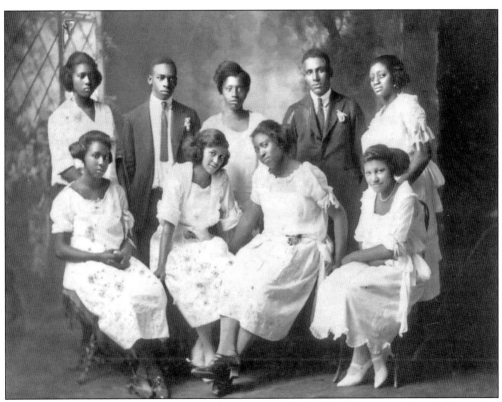

This is a photograph of the Bradley High School class of 1922. Shown are, from left to right, (seated) Elizabeth Jarrett, Robbie Claybourne, Kate Bright, and Corrine Jordon; (standing) Ethel Bright, Leon Simmons, Priscilla Williams, Acklen Johnson, and Mary Lizzie Douglas. Priscilla Williams later became a teacher and taught many students, including Dora Robinson Rucker. Priscilla Williams was the sister of Rose Williams McKnight and grew up on Sevier Street in Murfreesboro. (Courtesy of Ernestine Tucker.)

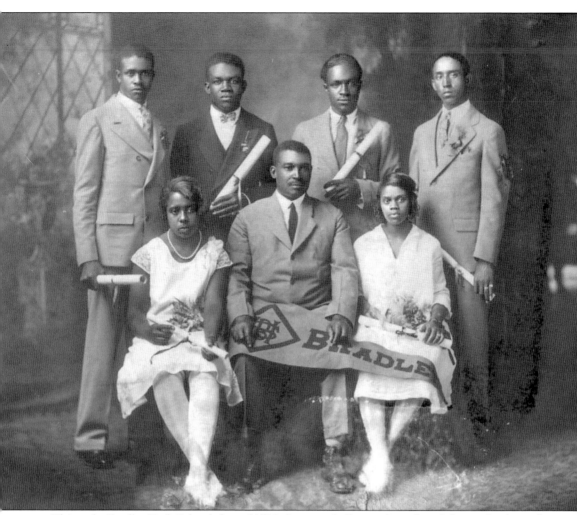

This is the Bradley High School class of 1926 photograph. Pictured are, from left to right, (seated) Lillie Bell Sanders, Professor Jones, and Henrietta Grisham; (standing) R. T. Butler, Roosevelt Seward, James Clark, and Eules Brown. R. T. Butler later became a winning Holloway High football coach, a member of many notable organizations (including H. Preston Scales Consistory No. 261), a 33rd-degree Mason, a member of Phi Beta Sigma fraternity, and principal of Bradley Academy. Henrietta Grisham, later Henrietta King, was a Sunday school teacher at Key United Methodist Church and an educator with the Rutherford County Schools. Roosevelt Seward went on to attend Fisk University, where he played football, and graduated from Columbia University in New York. (Courtesy of Ernestine Tucker.)

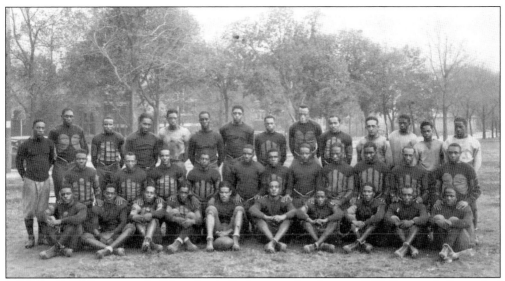

This is a Fisk University Bulldogs football photograph taken in 1927. Roosevelt Seward of Murfreesboro, uncle of Ernestine Burrus Tucker, is pictured at far left in the middle row. He went on to attend school and play football at Fisk University in Nashville. Not allowed to work and attend school, he then transferred to Columbia University in New York City, where he graduated, majoring in electrical engineering. (Courtesy of Ernestine Tucker.)

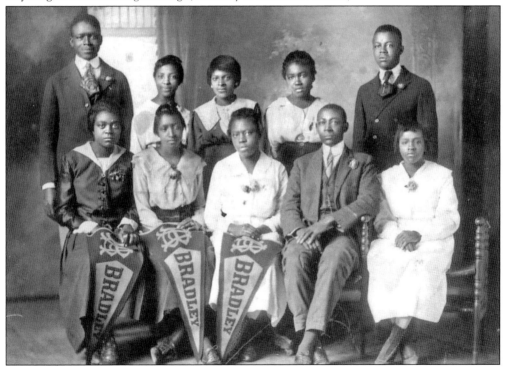

This early Bradley High School graduating class has the following people, from left to right: (seated) Ollie Sims, Johnnie Nelson, Sallie Mae Ewing, Professor Williams, and Polly Grisham; (standing) Willie King, Henrietta Vaughn, Minnie Hyde, Sallie Mae Seward, and Robert Johnson. (Courtesy of Ernestine Tucker.)

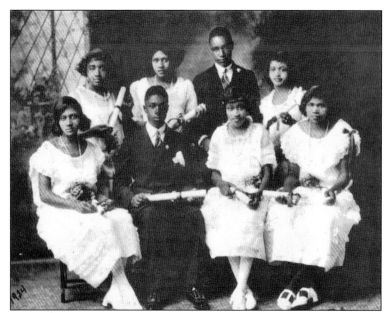

The 1924 Bradley Academy 11th-grade class included, from left to right, (seated) Fruzzie Burris, George Francis, Lillian Murray, and Marie Bright; (standing) Richinell King, Nevada Crenshaw, Calvin Johnson, and Geneva Bufurd. (Courtesy of Ernestine Tucker.)

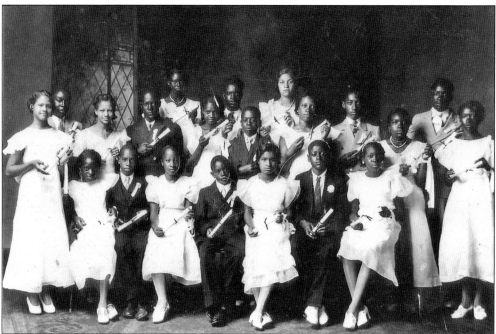

Mattie Butler graduates from eighth grade at old Holloway High School in this photograph. She is fourth from left in the second row, all dressed in white with her paper clutched in hand. Ruby Mae Scales, a daughter of Preston and Willie Burkeen Scales, is the tall girl standing in the back. Her parents founded Scales and Sons Funeral Home in Murfreesboro. It is said that when younger brother Robert Scales was born, she noted he was so small he was "Tee-nincy," or very small. The name was modified to "Tee-niny," and it stuck. There is a Murfreesboro City School named for the Scales family. Other classmates include Elizabeth "Lizzie" Butler, far left back row; Lemuel Dyson, far right back row; and Lucy Smith whose family still owns a successful Smith Brothers funeral home in Nashville, Tennessee. (Courtesy of Mattie Butler.)

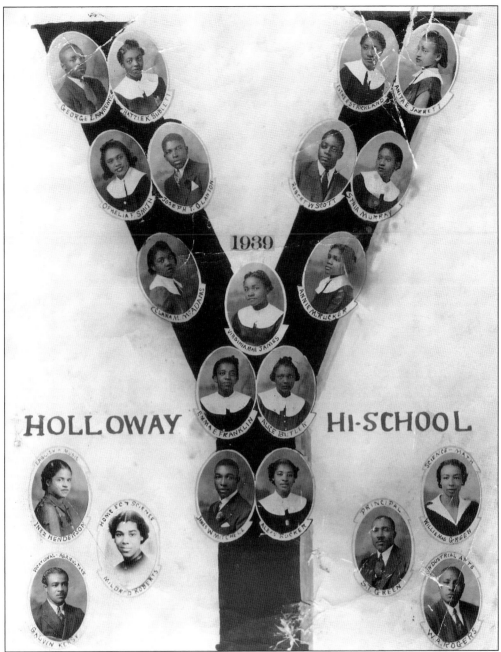

This is the 1939 graduating class of Holloway High School. At one time, the school used the letters in its name as the background of the senior class photographs. This is the last one, with the "Y" designated, before they began using the "standard" background for its graduation photographs. The principal is shown to be Samuel G. Greene. His name is printed incorrectly on the photograph. Annie M. Rucker Zachary became a teacher at the old African American Shiloh School, and Alice Butler Pettis, known as "Baby Sis," the daughter of Oscar A. Butler, married and moved to Detroit, Michigan. (Courtesy of Olivia Woods.)

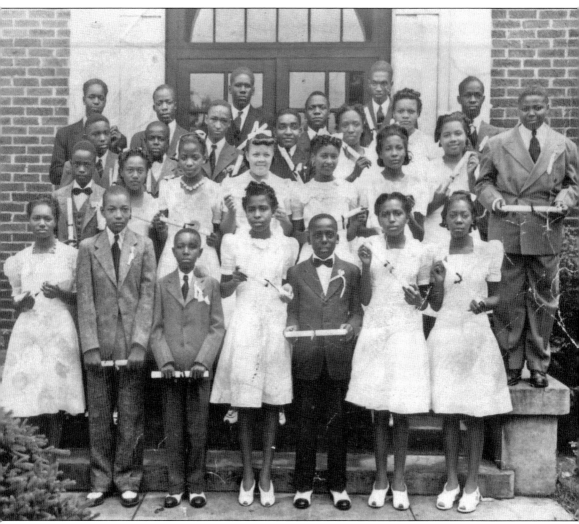

This is a Bradley Academy eighth-grade graduation photograph taken in front of Holloway, where the seventh- and eighth-grade classrooms were located. Class members in no particular order included Eddie Beatty, Gilbert James, Joe Bowling, L. Haynes, Minus Cason, Zack James, John Roberts Spain, Verlie Zachary, Mary Dean Smith, ? Brown, Freddie Lyons, Corrine Smith, Dolores Williams, Wilma Scales, Katie Huddleston, Elmadean Knight, Johnny Murray, Christine Miller, Ewell Overton, Sam Batey, Willa McIntyre, and Prince Edward Etta. Dolores Williams was the only child of Rose Williams and the granddaughter of Rose P. Overall. All three generations lived at 522 East State Street and were members of Key United Methodist Church. Dolores later married James "Link" Butler Jr. (Courtesy of James L. Butler Sr.)

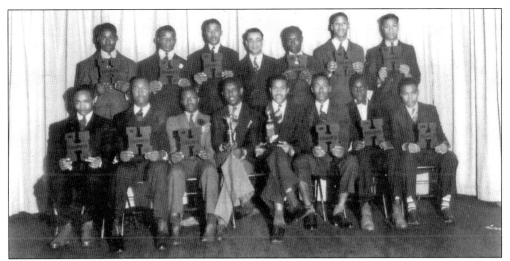

This is a 1940 Holloway High Bears football picture. The team was undefeated in 1940 and 1941. In 1940, they won nine games. From left to right are (first row) Isaac Crawford, James Reece, Willie Lewis, coach Weber Smith, coach R. T. Butler, Clem Richardson, Paul Stevenson, and Richard Woodard; (second row) William Windrow, Joseph Vaughn, Robert Rucker, coach G. K. Kersey, Roger Brown, Joe Brown, and Eugene Johnson. (Courtesy of Ernestine Tucker.)

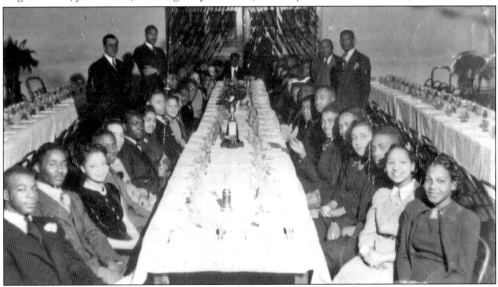

This photograph was taken in the chapel at the 1941 Holloway High School football banquet in Murfreesboro. The trophy sits in the center of the long table. The Holloway Bears team went all the way to state and won the Little Tennessee (Negro) Conference. R. T. Butler was the head coach, W. R. Smith end coach, Galvin K. Kersey backfield coach, and William Rogers line coach. From left to right are (left side of table, from front to back) Joe Vaughn Jr. (captain), William Winrow, Georgiana Avent, Willie Lewis Jr., Laura Haynes, Rogers "Mike" Brown, Laris Rucker, Eugene ("Goody") Johnson, Odestine Rabon, Richard Woodard, Margaret Vaughn, Wash James, Alean Rucker, Howard Rucker, and two unidentified. Standing from left to right are G. K. Kersey, R. T. Butler, Prof. S. G. Greene (center), William Rogers, and Weber Smith; (right side of table) Ernestine Burrus, Mary F. Willis, Charles Ledbetter, Gareldine Black, Isaac Crawford, Robert Rucker, unidentified, James Reece, unidentified, Paul Stevenson, and the rest are unidentified. (Courtesy of Ernestine Tucker.)

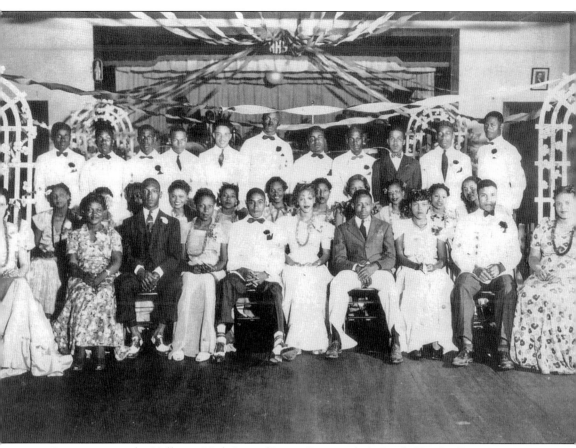

Participants at the Holloway High Junior/Senior Prom include Picola Knight, Dora M. Mason, Pauline Lyons, Mildred Turntine, Willie Willis, Gladys Stewart, Mary Francis Willis, Alean Rucker, ? Ransom, Lee Overton, Frances Moore, Sadie Elizabeth Etta, Jim Brandon, Dorothy Smith, L. G. Murray, Robert Woods, Inez Kersey, Dudley Frazier, Charles James, Alonza Etta Jr., Billy Beatty, Oliver Zachary, Willie D. "Panic" Miller, Burnice Vaughn, Andrew Mitchell, and Howard Rucker. Howard Rucker became a barber in town and at one time had his shop on Hancock Street located in Murfreesboro Lodge No. 12. He also worked at the airport in Nashville. (Courtesy of Ernestine Tucker.)

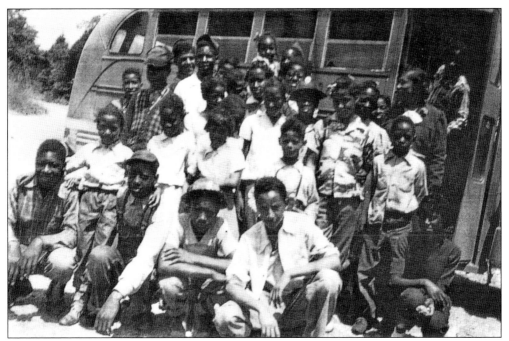

Arena Mack Tillage, a teacher at old Locke Elementary School, shown in this 1950s photograph, stands looking over to her right as the student body is photographed in front of the school bus. (Courtesy of Mary Jane Johnson.)

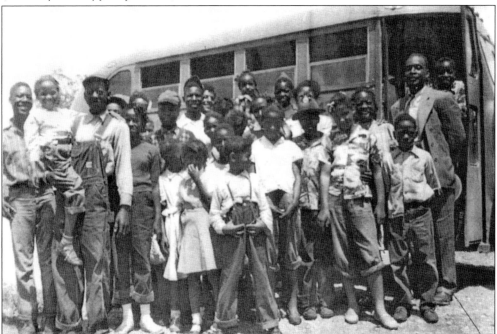

Locke Elementary was an African American Rutherford County school. These students are posed for a photograph in front of the school bus. Aaron Wade, standing in front of the door of the bus in a suit, was a teacher there. Wade at one time operated several businesses in town, including a dry cleaning business. (Courtesy of Mary Jane Johnson.)

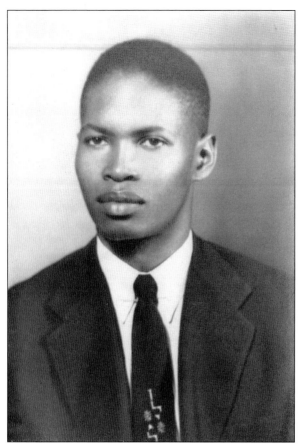

This is a handsome young native of Rutherford County, Oscar Perry Butler Jr. His parents, Oscar Perry Butler Sr. and Emma Augusta Ransom, at one time lived on University Street in Murfreesboro. After the death of his parents, he went on to live with his grandmother, Annie Bell Spain Butler, moved to Nashville where he attended Pearl High School, and received many basketball honors. In a documentary, he details how he once dug ditches and served in the military. He also graduated from schools in Michigan and South Carolina and earned his Ph.D. He became a dean with South Carolina State University, where he has since retired. He is a member of Kappa Alpha Psi fraternity. His life and his contributions to the history of African American basketball in this country are detailed in a 2008 ESPN documentary titled *Black Magic*. Dr. Butler, retired, now lives in Orangeburg, South Carolina, with his wife, Barbara. (Courtesy of James L. Butler Sr.)

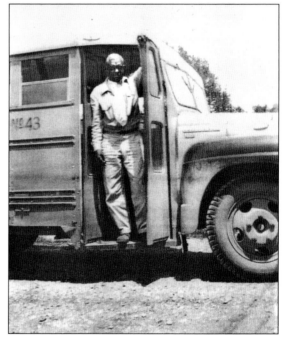

Eugene Hill is posed in the door of his bus. He was a bus driver for Locke Elementary School, according to Rutherford County school records. (Courtesy of Mary Jane Johnson.)

A vibrant and young Stella Butler (far left), daughter of Mattie and William Butler, graduates from Bradley Nursery School kindergarten. Other class members include, from left to right, Neal Black, Diane Kersey, Bessie Woods, Horace Butler, and Carolyn Cason. This photograph is identified as taken in front of the house of educator Lillian Hammons, the class teacher. Hammons was the school's founder and served as its director for over 70 years. Bradley Kindergarten School was formed when the enrollment grew too large for the Bradley Nursery School to absorb. Bradley Kindergarten existed from 1958 to 1966. (Courtesy of Mattie Butler.)

This is the 1961–1962 graduating class of Rutherford County native Collier Woods Jr. (far right, back row), proudly smiling as he graduates from Bradley Nursery School. He still possesses the same outgoing and exuberant personality. (Courtesy of Olivia Woods.)

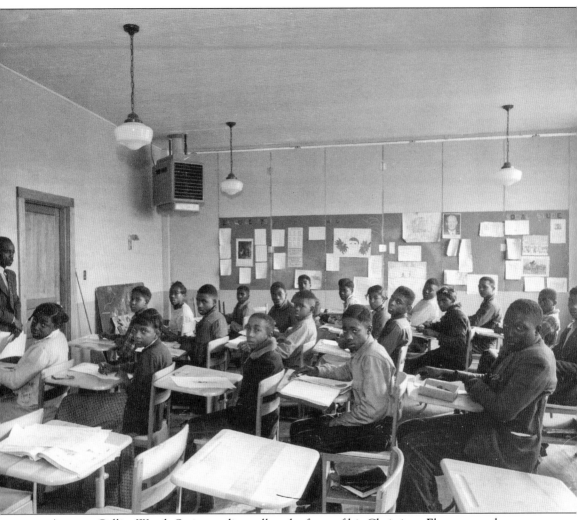

A young Collier Woods Sr. is standing tall at the front of his Christiana Elementary classroom, as identified by young student Florence Smith, seated second from the back, with a white bow, facing the camera. The picture of Dwight D. Einsenhower looks down upon the class to give an idea of the time period. Mrs. Collier Woods Sr. recalls her husband giving both Florence and her sister Katie a ride to school in the morning. George Woods, eldest son of Mr. Woods, recalls the siblings as being in upper grades and has many stories of having his father as a teacher at his school. (Courtesy of Olivia Woods.)

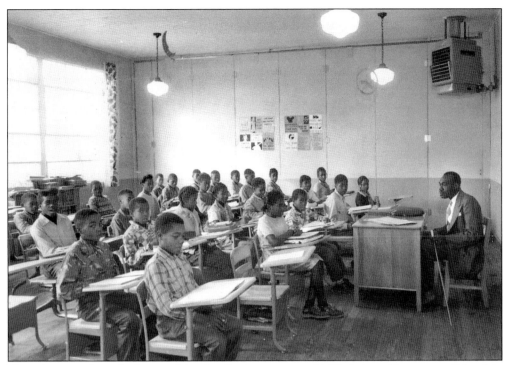

This photograph is of educator John Lord's classroom at old Christiana Elementary School in Rutherford County. John Lord was the husband of Myrtle Glanton Lord, a former Murfreesboro, City Schools educator for whom a branch of the Linebaugh Library System was named. (Courtesy of Olivia Woods.)

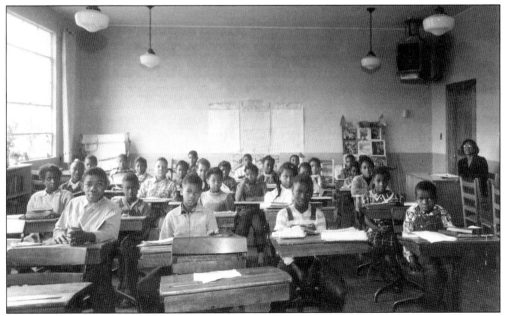

This is a photograph of Mrs. Miller's classroom at the old African American Christiana Elementary School. She was the wife of former Allen Chapel AME pastor Rev. S.W. Miller. (Courtesy of Oivia Woods.)

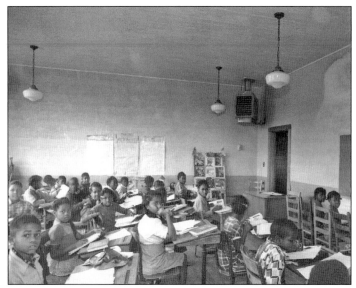

Mrs. Miller's bright-eyed Locke Elementary School students are posing for the camera. According to Rutherford County school records, the school boasts family names of Howse, Batey, Blackman, Jobe, and Pope. Cooks for the school were Allie B. Hill, Sallie B. Smith, and Carrie B. Carney. (Courtesy of Olivia Woods.)

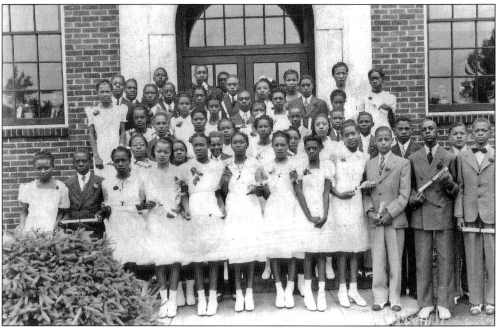

This is the 1940 graduation class from Bradley School. James "Link" Butler is second row down from the top and fourth from the left. Robert "Tee-niny" Scales is second from right from the front, and Houston Overton is first row, third from right. Others assembled include Margaret Vaughn, Robert E. Lewis, Charlie D. Childress, Claudine Lytle, Dorothy Lyons, Dora McKnight, James Coppage, Catherine Hayes, Jesse Norman, Orajeane Akins, Janie Belle Coppage, Florence B., Mayola Strickland, Addie Ruth Rucker, Carolyn Mitchell (mother of pro ball player Dennis Harrison), Eugene Stevenson, James E. Avent, Christine Watkins, Jim Brandon, Henrietta Bass, Josie Mae Davis, Effie Lee Childress, Jimmie Murray, Andrew Mitchell, Edmund "Devil Ham" Lytle, Billy Beatty, James Reece, Delbert Smith, Willie Bell Lockett, R. McIntyre, Kathleen Grissom, Calvin "Coon" Simpson (a great runner, Butler recalls), and Joe Williams. (Courtesy of Houston Overton.)

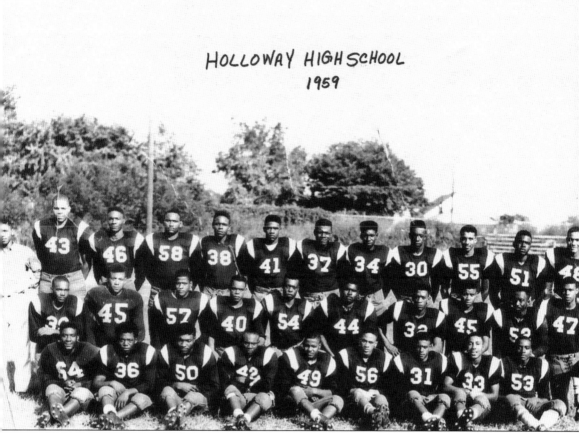

This is a photograph of the Holloway High School 1959 football team. From left to right are (first row) Robert Ransom, Sam Wallace, Joe Ward, Gordan Johnson, James "Tommy" Davis, Aaron Wade Jr., Frank McClain, Curtis Sneed, and Harold Johnson; (second row) Neal Black, Joe Batey, Jeffrey Fletcher, Richard Scott, Luther Roper, James D. Stevenson, James Swafford, James Cannon, Reedy Floyd, and James Robert Vaughn; (third row) Steve Sneed, Kenneth Tillage, Robert Rucker, Will Simmons, Nathaniel Smith, Joe Williams, George Wade, Robert Rankins, Robert Wright, Joe Floyd, James McAdams, and Gerald Willis. (Courtesy of Houston Overton.)

Pictured here are Julia Hattie Bass Butler (standing), Ruby Lee Goodman (left), and an unidentified woman. According to Rutherford County school records, Julia H. Bass was an educator at Little Hope School in Rutherford County, among other schools. She was the sister of educator Roberta Bass Goodman. Julia married Hosea Butler of Rutherford County. Hosea Butler at one point drove a bus that could be caught from the "Mink Slide" to Nashville, Tennessee. This mink slide is the portion of South Maple Street that extended from Vine Street to approximately where Holden's Hardware stands today. Hosea and Julia were members of Gray's Chapel United Methodist Church in the Dilton area for many years, and when the church was closed, they later joined Key United Methodist Church. They lived on Mount Herman Road in Rutherford County. This photograph is of a group on a trip to Nashville to enjoy a riverboat ride. (Courtesy of Mary Jane Johnson.)

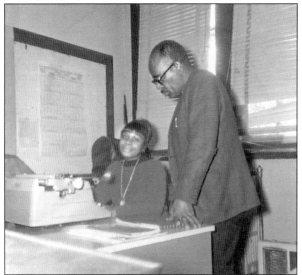

This December 1968 photograph is of Collier Woods Sr. and his secretary, Doll Sue Lewis, in the office at old Holloway High, where he served as principal until integration at the end of the 1968 school year. Later, with the building of two new schools, Oakland High and Riverdale High, he was appointed vice principal of Oakland, where he served until his retirement. (Courtesy of Olivia Woods.)

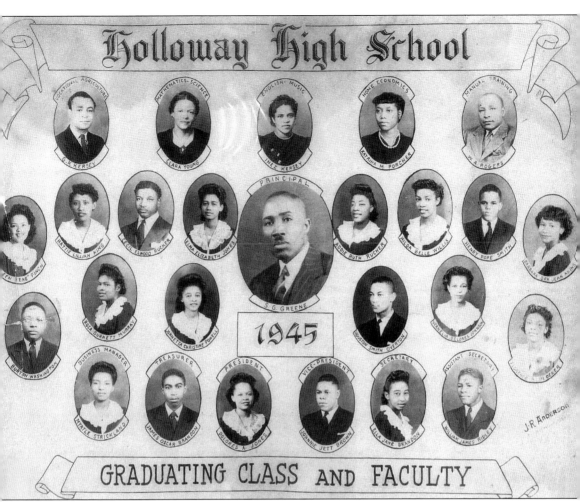

The 1945 graduating class of Holloway High School included Ella Jane Brandon and Houston Overton, who went on to marry and are still married today. What is interesting to note about Ella Jane Brandon Overton is that the retired educator has a collection of elephant memorabilia that numbers over 1,000. (Courtesy of Houston Overton.)

Olivia Murray Woods is a retired educator in the Murfreesboro City School System. She is a graduate of Tennessee State University and was the first African American to receive a bachelor's degree from Middle Tennessee State University in Murfreesboro in 1965. She married Collier Woods and raised daughter Deborah and sons George and Collier Jr. (Courtesy of Olivia Woods.)

Collier Woods Sr. was a member of Allen Chapel African Methodist Episcopal Church for many years. He served in the navy and returned to Rutherford County to continue as an educator. Woods married 1939 Holloway High graduate Olivia Murray and raised three children in Rutherford County. The family lived with his parents on Sevier Street when they were first married and later moved to the corner of Mercury and Carver Streets in Murfreesboro. (Courtesy of Olivia Woods.)

Mattie Butler is shown here. The widow of William "Sneak" Butler, she is a retired educator, member of the local Delta Sigma Theta graduate chapter, and the recipient of many community awards. She served as the vice president of the local Democratic Women's group and local president of the Federation of Colored Women's Clubs in 1952. She grew up on Sevier Street in Murfreesboro and recalls seeing the circus come to town at the fairgrounds, then located where the current Patterson Community Center is. She is a member of Allen Chapel African Methodist Episcopal Church. (Courtesy of Mattie Butler.)

William "Sneak" Butler was the first African American to serve on the Murfreesboro City School Board. He was a member of Murfreesboro Lodge No. 12 and was a career educator in the school system. According to the Rutherford County Schools records, he taught at Squirrel Hill School, and when enrollment during cotton picking time became irregular, Butler talked with the parents, children, and the farmers. Through combining their efforts, the children went from farm to farm and not only had all the cotton picked in one week's time but had money to donate to the American Red Cross. "Sneak" Butler received numerous awards in his time, but his wife, Mattie, notes his belief in suffrage was so strong that while hospitalized and too ill to travel otherwise, he cast his vote in an ambulance during an election. The home of his father, both a carpenter and a preacher, is said to have been on the corner of State and University Streets. William "Sneak" Butler was a longtime member of Allen Chapel African Methodist Episcopal Church. (Courtesy of Mattie Butler.)

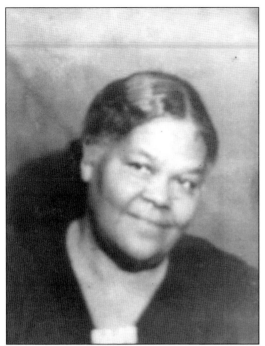

Bertha Green was a teacher of fifth grade at old Bradley School. In 1934, the fifth grade was split and R. T. Butler took half the class, recalls Ernestine B. Tucker. Bertha Green was a member of Key United Methodist Church. This highly respected educator lived with her sister, Allie, on State Street. The house is still standing. The students referred to her as "Big Chief," for she was a staunch disciplinarian. According to Rutherford County school records, she was also a teacher at Little Hope School in Smyrna. (Courtesy of Ernestine Tucker.)

This is the former home of Bradley School educator Vertress Woodson, sister of Eugene "Genie" Woodson, located on Highland Street in Murfreesboro. The house no longer stands. Rutherford County records indicate that Woodson was a teacher at old Mount View School, which existed from approximately 1870 to 1918. According to its history at the church, the land was given for the school by Clem Ross in 1870. Queen E. Washington, the granddaughter of Ross, is the mother of L. Elaine Washington, a Rutherford County Schools educator. (Courtesy of Olivia Woods.)

This is a photograph of educator and Rutherford County native Andrew Dunn, a former Hickory Grove School student. His wife, Ann, recalls how they were introduced by a mutual friend while he was attending college in Nashville. The couple raised three boys and lived on Woodbury Road in Murfreesboro. They were married for 47 years. Ann received induction into the Tennessee Teacher's Hall of Fame and is retired from teaching. (Courtesy of Ann Dunn.)

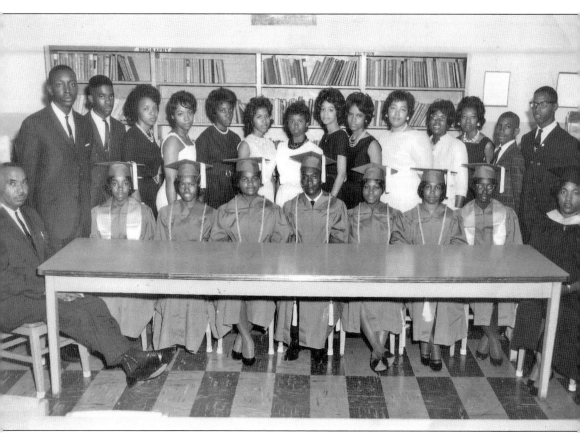

This is a 1960s photograph of the Holloway High National Honor Society taken in the school library. From left to right are (first row) Principal J. H. Stevens (at one time the supervising principal of both Bradley and Holloway Schools), Lenora Elaine Washington (salutatorian), Ruby Johnson, Tula Odell, Richard Butler (president), Rachel Lewis, Cora McHenry, and Sarah Gooch (valedictorian); (second row) Leonard Zachary, George Woods, Charlotte Tillage, Shirley Bingham, Jernita Hite, Mildred Mosby, Alice Faye Richardson, Lucy Butler, Freda Hughes, Kathryn Knight, Shirley Bright, Nancy Wade, Bryan Motley, and Hany Alexander. J. H. Stevens and his wife, Dorothy, were both members of Key United Methodist Church in later years. Zachary was a talented musician whose family lived on Sevier Street. L. Elaine Washington, daughter of noted educators Queen E. and A. D. Washington, who taught at Smyrna Rosenwald School, became an educator in the Rutherford County Schools, and Kathryn "Kitty" Knight also became a Rutherford County Schools educator. Knight is a member of Key United Methodist Church. (Courtesy of Houston Overton.)

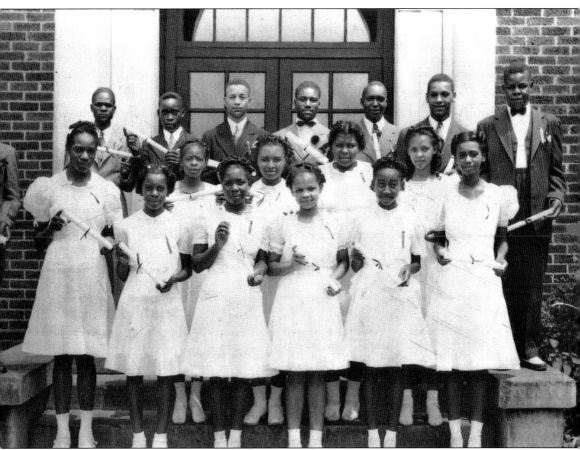

This is a 1941 Bradley School graduation class in front of Holloway High. Ella Jane Brandon is in the first row, second from the right. She went on to teach for over 40 years in Rutherford County. Others pictured, in no particular order, are Johnny Jett Brown, Dolores Jones, Elma Jones, Catherine Hayes, Hilda B. Willis, Susie Miller, Myrtle Strickland, Sarah Williams, Kathleen Finch, Joe Brown, Johnny Ransom, D. H. Murray, James Preston, and young man James Ridley, nicknamed "Pig Tail." (Courtesy of Houston Overton.)

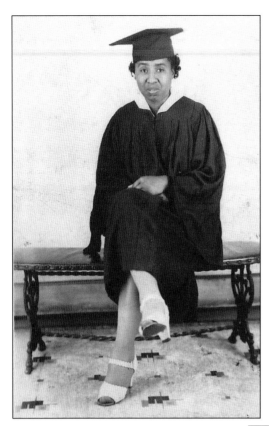

This photograph of a young Dora Rucker was taken upon her graduation from the Queen of Sheba Beauty School in Nashville. Her graduating class was the first African American group to use the War Memorial Building for graduation ceremonies. She married Chester A. Rucker of Rutherford County. She lived on Maney Avenue with her husband and was a hairstylist in the area for many years. She began selling Avon in 1946 and continues to take limited orders even today. She is currently 98 years old and still vibrant and residing in Murfreesboro. (Courtesy of Ernestine Tucker.)

Willa Kimbro Foster was a student at Antioch School in the Leanna community. Her classmate and seatmate was Dora Robinson. A former educator listed as faculty of many Rutherford County Schools, including Shiloh Elementary, she was the longtime pianist and a member of Key United Methodist Church in Murfreesboro. (Courtesy of Dora Rucker.)

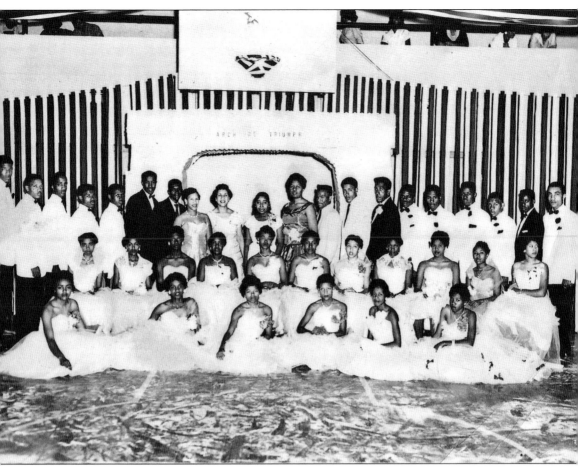

Teacher Ella Jane Overton (back row center) is shown here with a Holloway High Junior/Senior Prom group, with participants including teacher Dorothy Stevens and students Fred Malone, Gladys Howse, Jesse Brown, and Pawnell Williams, among others. (Courtesy of Houston Overton.)

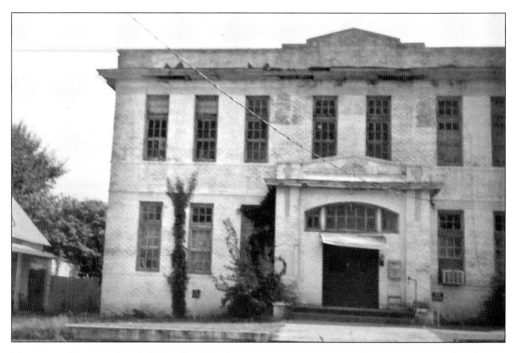

These are photographs of old Bradley Academy prior to renovations. Former U.S. president James K. Polk was once a student at the school. In 1884, the school was used for the education of African American students. It is now the site of Bradley Academy Museum and Cultural Center. (Both courtesy of Olivia Woods.)

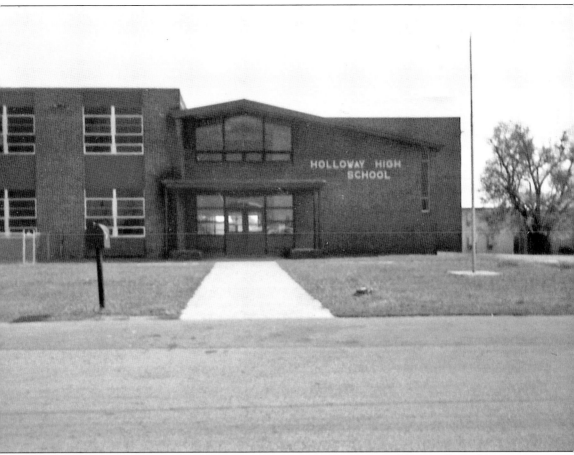

This is Holloway High School as it looks today. The left side of the building is where the annex once existed. It first opened its doors to African Americans in 1929, with Bradley Academy graduating African American students until then. Bradley Elementary School peeks out from the right side of this photograph. The current elementary school was renamed Bradley Academy to pay homage to its historic namesake. (Courtesy of Olivia Woods.)

Holloway High School is shown as it looks today. The Middle Tennessee Colored Fair took place there for many years behind the school, approximately at the site where Patterson Community Center now stands. A 1949 "Mid-State Fair News" notes that the fair had been going on since 1939 at that point. Six counties were participating at that point, and newspaper contributors included R. T. Butler and Mary Ellen Vaughn; an unsigned article mentioned the pride all took in the success of Jackie Robinson and the denouncing of Southern "Jim Crow laws." The paper listed the all-male fair officers and directors as W. E. Harlan, president; Merle H. Eppse, vice president; Lee Leslie, treasurer; William H. Butler, secretary; Turner Peebles, coordinator; and directors Fletcher Pinkerton, Obid Strickland, Eugene Hill, and John Bracey. Barbecue Hostess Committee members were Hilda Belle Willis (head), Evelyn Lewis, Magline Williams, and Grace Mai King. Joseph E. Vaughn Sr. was mentioned as senior public relations chair for the group, and his son, Joe Jr., was noted as director of Holloway Park. Tennessee state governor Gordon Browning was to attend the fair, and Betty Swafford and Rose Keeble were to assist in serving the Governor Barbecue at a luncheon during the festivities. Rutherford County native Henry Beard, owner of Beard Stables on Woodbury Road, was noted as the owner of the 1948 winner of the fair horse show. White horse stables had a show sponsored by white supporters, and African American stables were allotted a separate event show. One fair attendee recollects her parents taking her to enjoy the rides, the exhibits, and the numerous visitors there to be seen. The Tennessee State Assembly was asked to assist in establishing the fair. (Courtesy of Olivia Woods.)

Two

THE MILITARY

This is a photograph of Berry Richmond Seward, born September 26, 1898, and he died March 30, 1975. He was gassed in France in World War I and was awarded the Purple Heart medal. He later moved to Detroit, Michigan, and is buried there. As the first black electrician in Murfreesboro, Berry Wesley Seward, the father of the soldier who shared his name, was a former slave that at one time was one of the oldest members of old Key Chapel. (Courtesy of Ernestine Tucker.)

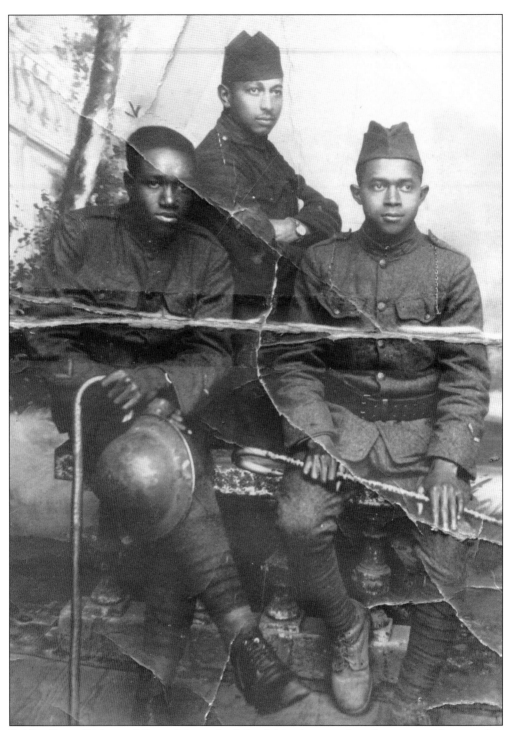

Soldier Berry Richmond Seward is on the left of this photograph as he poses with two other soldiers in France in 1918. He was gassed while in France and received the Purple Heart medal. He returned from his service overseas speaking French, recalls his niece. (Courtesy of Ernestine Tucker.)

This is a service photograph of James R. Burrus, Rutherford County native and uncle of Ernestine Burrus Tucker. He was born on October 20, 1888, and he enlisted in the service in 1918. He was honorably discharged on August 7, 1919. (Courtesy of Ernestine Tucker.)

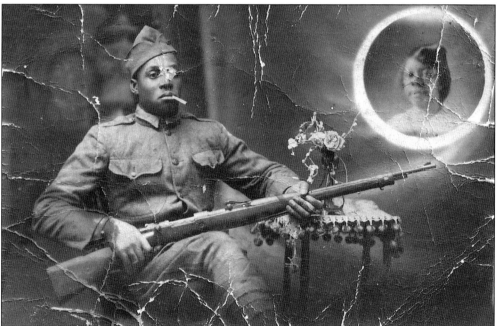

A young Word War I soldier thought to be named Howard Johnson poses seated with a cigarette and gun. The interesting twist is that there is a picture inset of a young woman, seemingly his sweetheart, on the right. (Courtesy of Mary Anne Smith.)

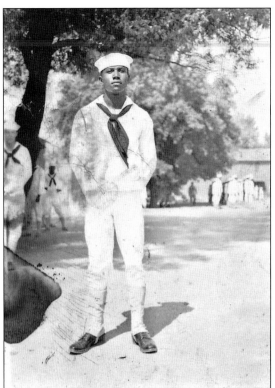

Handsome sailor William Vaughn, known as "Billy," went on to marry Helen Gregory and raise a family. Helen Gregory Vaughn is a lifelong member of Elders Chapel United Methodist Church in Smyrna. Gregory's mother, Queen Victoria, still has a special day celebrated in her honor annually. (Courtesy of Ernestine Tucker.)

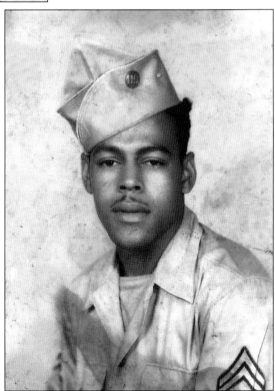

Handsome Murfreesboro native James R. Vaughn, nicknamed "Stack," is shown in military uniform. (Courtesy of Ernestine Tucker.)

This is a picture of a young William H. Butler with his brother Horace to his left posed in his navy uniform. William H. "Sneak" Butler was a member of Phi Beta Sigma fraternity. He ran unsuccessfully for the Murfreesboro City Council; however, he served as president of the local NAACP from 1957 to 1984. He and his wife, Mattie, raised six children. (Courtesy of Mattie Butler.)

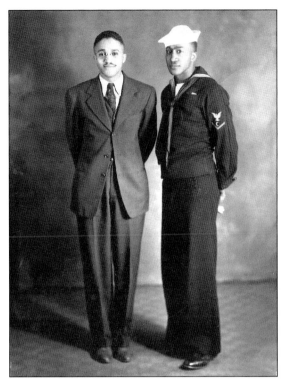

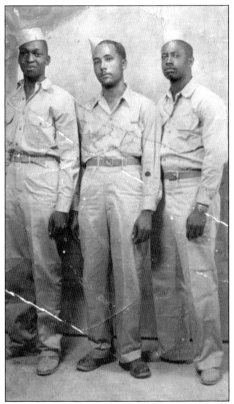

This is a picture of handsome Tommie Lee Smith (thought to be far right) in his service uniform with friends. Tommie Lee Smith was the brother of Georgia Smith, who lived on State Street in Murfreesboro. (Courtesy of Mary Anne Smith.)

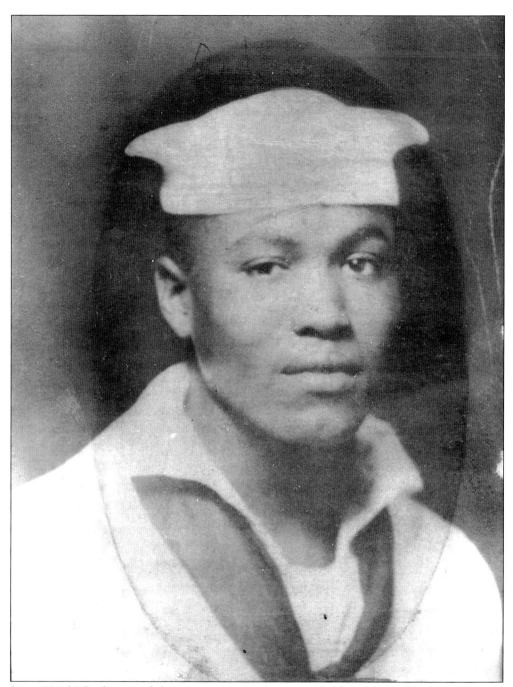

James "Link" Butler served during wartime in the navy. His date of enrollment was June 2, 1943. He was stationed in Hawaii. He recalls boxing as a sport for which he trained. After being drafted, he returned to Holloway High in Murfreesboro and graduated in the class of 1947. He later served as commander of the local Veterans of Foreign Wars. He worked for many years in various dry cleaning businesses and finally for Richard Smiley of Smiley's Cleaners. He was the primary worker in the business for several years and was hired from there to the General Electric factory in town. (Courtesy of James L. Butler Sr.)

Chester A. Rucker of Rutherford County was an army service member in the tank battalion and served as a quartermaster in the tank unit. He served in the South Pacific during World War II, where he attained the rank of sergeant. He attended school in the Emery community and later entered carpentry school at Seward Air Force Base. He worked as a barber and a carpenter at Seward Air Force Base until it closed in the early 1970s. He joined Emery United Methodist Church at an early age where he taught Sunday school. He later joined Key United Methodist Church. He, along with Elizabeth Drew, founded and taught the Community Bible Class in the mid-1970s. He was married to Dora F. Robinson for over 60 years. (Courtesy of Dora Rucker.)

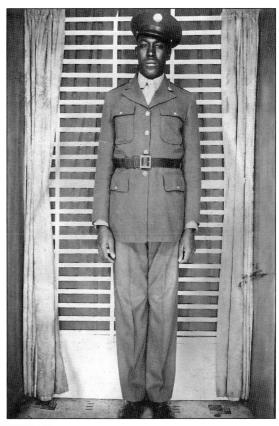

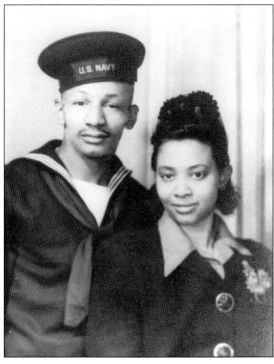

This is a cousin of Murfreesboro native Dolores Williams Butler. Here he looks quite handsome in his navy uniform with his girl at his side. (Courtesy of James L. Butler Sr.)

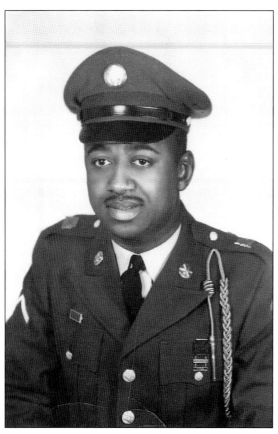

This is J. W. Robinson in his army uniform. Later retiring as a teacher in the Rutherford County School System, he was a member of the faculty at the segregated Shiloh Elementary in Rutherford County. He recalls Nannie George Flowers Rucker as his principal at Shiloh, with Willa Kimbro Foster and Annie Rucker Zachary as former educators on staff. (Courtesy of Dora Rucker.)

This is a photograph of a Veterans Banquet at old Holloway High School. (Courtesy of Ernestine Tucker.)

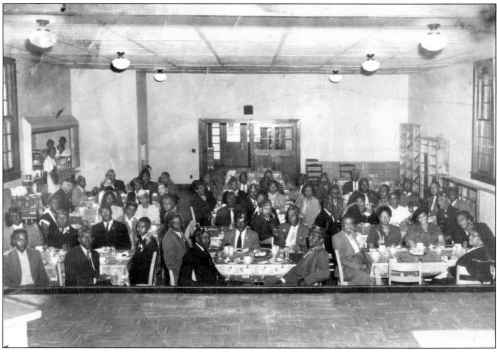

Eugene Franklin Jr. of Murfreesboro
was an army service member. He
attended Holloway High School in
Murfreesboro and lived on University
Street. (Courtesy of James L. Butler Sr.)

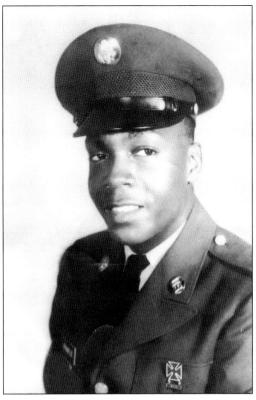

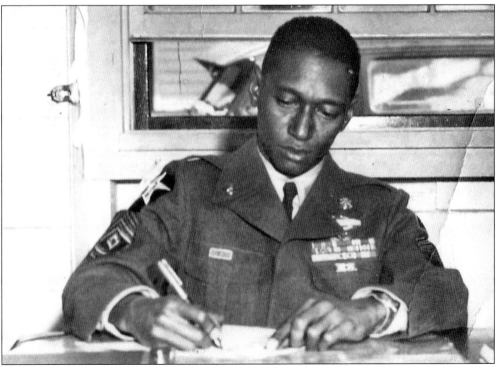

This soldier, shown here signing a paper, is unidentified. (Courtesy of James L. Butler Sr.)

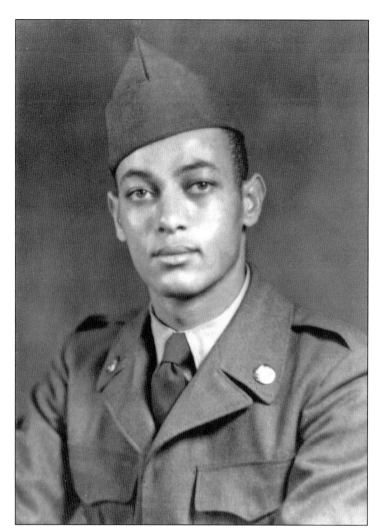

Houston Overton Sr. was born in Nashville, Tennessee. He is shown here in his military uniform. He served in the Korean War from 1952 to 1954. He tells a story of how his father came to the area to work at the Alvin C. York Hospital in February 1940. He worked as a postal worker for 27 years, now enjoys fishing, and has a very large model car collection. He is very well traveled and a longtime member of First Baptist Church in Murfreesboro. (Courtesy of Houston Overton.)

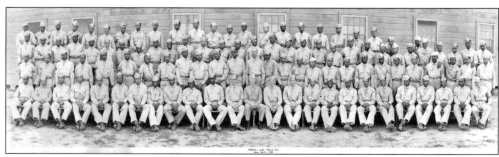

A young handsome Chester Rucker is shown in this picture of the 3460th Quarter Master Truck Company taken on September 4, 1944. He is standing in the second row, ninth from the left. (Courtesy of Dora Rucker.)

Three

FACES AND PLACES OF RUTHERFORD COUNTY

A young Theodore Roosevelt Seward is posed and pensive in this photograph. The son of a former slave, the college-educated electrical engineer had many hobbies, including photography and playing the ukulele. The Rutherford County native was featured in *Our World Magazine* in February 1952 in recognition of his life accomplishments. (Courtesy of Ernestine Tucker.)

Local seamstress Clara Beard, "Aunt Clara" as many called her, was also known to be quite a cook and cateress. She later lived on Mercury Boulevard in Murfreesboro and was a member of Prosperity Baptist Church in the Dilton community upon her death. It is recalled that she had a boisterous and joyful laugh and smile. (Courtesy of James L. Butler Sr.)

POLL TAX RECEIPT

RUTHERFORD COUNTY, TENN.

No. 220

Murfreesboro, Tenn. _____ 19___

Received of _____

the sum of _____ DOLLARS,

in full for Poll Tax for the year 1919 in District No. _____

CULLOM ALEXANDER, Trustee.

$ _____ By _____ D. T.

MARSHALL & BRUCE CO., NASHVILLE

This is a copy of two poll tax receipts, dated 1920 and 1923, that were received by Jesse Alexander upon his payment of $2 for the privilege of voting. His daughter Elodie Alexander Batts notes that he accumulated quite a few of them over time. The amount paid was a financial stretch back then but worth exercising a right that was once denied to many in his lifetime. (Both courtesy of Elodie Alexander Batts.)

POLL TAX RECEIPT

RUTHERFORD COUNTY, TENN.

No. 181

Murfreesboro, Tenn. _____ 192 3

Received of Jess Alexander _____

the sum of _____ Two _____ DOLLARS,

in full for Poll Tax for the year 1922, in District No. _____

T. M. VAUGHAN, Trustee.

$2. _____ By _____, D. T.

21110 MARSHALL & BRUCE CO., NASHVILLE

Oscar Alfonzo Butler was the son of Perry and Alice Henderson Butler, born on Woodbury Road in Rutherford County. He was a farmer, had only a third-grade education, and had four children by his first wife, Annie Bell Spain Butler. He owned a wagon and a team of mules for hire. He was also known to be quite the political official, carrying African American voters to the polls and being visited by the local politicians of the day. He was a longtime member of Prosperity Dilton Baptist Church in Rutherford County. This was a photograph taken by his brother-in-law Jesse Jarman, a professional photographer who married his sister and had a studio in Indianapolis, Indiana. (Courtesy of James L. Butler Sr.)

Oscar Alfonzo Butler is sitting in a chair propped back against the house on his porch. Also, Butler, a farmer and third-generation owner of the only African American Century Farm in Rutherford County, sits in his overalls enjoying the view of old Woodbury Pike. Oscar died in 1970. The house remains today and is owned by his son James. (Courtesy of James L. Butler Sr.)

Mae Sue and Jesse Alexander are the parents of Elodie Alexander Batts. The Alexanders lived in the Dilton area of Rutherford County. However, Mae Sue had a brother, Pete Clark, who lived across the street from Oscar Butler on Woodbury Road. Elodie Batts recalls getting dressed up after getting a call that Jesse Jarman, Lucille Butler Jarman's photographer husband, was in town and going to visit Oscar's to get a photograph taken. This was taken in front of Oscar's house on Woodbury Road, with the porch and the rock first step. Batts noted that many a rural family would have a Jarman photograph on their shelf that they would not have been able to afford otherwise. He stamped his photograph with his studio stamp: Jarman Studios, Indianapolis, Indiana. (Courtesy of Elodie Alexander Batts.)

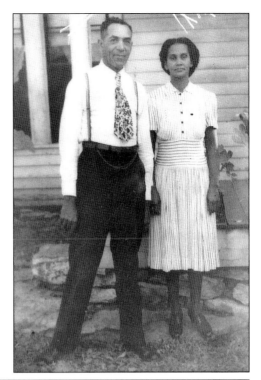

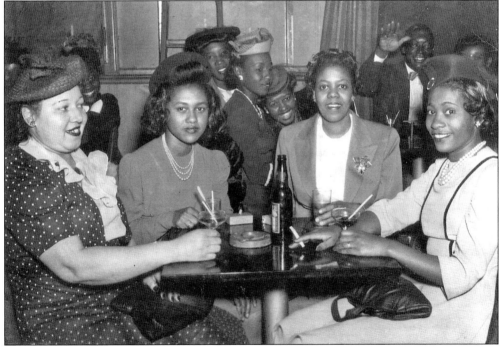

These young women are posed for a nightclub photograph on a trip to Washington, D.C., to visit former Holloway High School class of 1939 graduate Ophelia Smith (second from the right), who was married and living there at the time. Olivia Woods is on the far right with Magnolia Lyons on the far left. The other person is a friend from D.C. (Courtesy of Olivia Woods.)

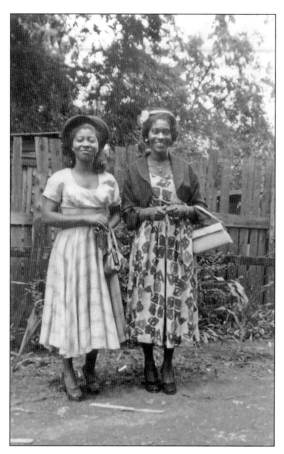

Mattie Woods and Olivia Murray Woods, sisters-in-law, pose for the camera. Both married brothers, Olivia to Collier and Mattie to Herschel. The former African American newspaper the *Murfreesboro News* (Pearl Wade, editor) published the obituary of Herschel Woods in a 1960 issue. (Courtesy of Olivia Woods.)

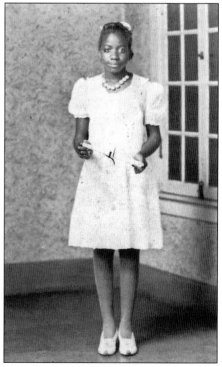

Shown here in her graduation photograph from eighth grade at Bradley Academy, Dolores Williams Butler grew up on East Sevier Street, across from friends and fellow church members America Douglas and Christine Miller. She was a lifelong member of Key United Methodist Church, where she served in the Women's Society, Communion Stewards, and the United Methodist Women. She went onto marry fellow Holloway High School graduate James L. Butler Sr. and raised eight children. (Courtesy of James L. Butler Sr.)

This young man is the father of Ernestine Burrus, entrepreneur John Henry Burrus. He opened a restaurant, the Cedar Circle Grill on Sevier Street, in 1939. Later he opened up a barbeque pit in front of the establishment for a short time, in partnership with local teacher Aaron D. Wade. He died at the age of 49 after saying a prayer, states his daughter, in the then newer location of Mount Zion Primitive Baptist Church, which is still in existence today on Mason Court in Murfreesboro. The original Mount Zion Primitive Baptist Church was located on State Street close to the area called "the bottom," so named because of its sloping terrain. (Courtesy of Ernestine Tucker.)

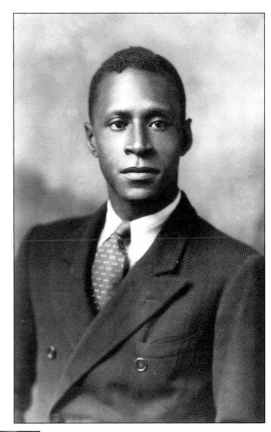

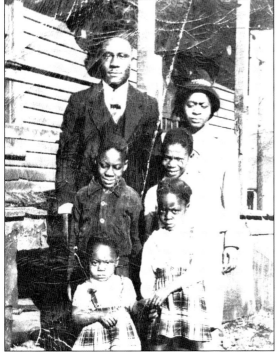

Mary Jane Johnson is posed here with her family outside of their home. Mary Jane, lower left, is about two years old in this picture and went on to attend Locke Elementary in Rutherford County with her siblings. Her family at one time owned a store in Davidson County, where she was born. She later moved to the Little Hope community of Rutherford County. In adulthood, she was a hairstylist in the area for over 25 years. Her sister, Dorothy, beside her and dressed alike, lives in Smyrna and is a longtime member of Elders Chapel United Methodist Church. (Courtesy of Mary Jane Johnson.)

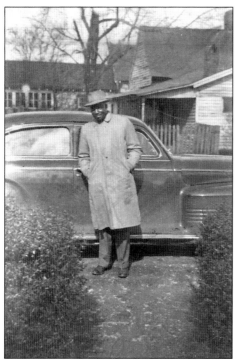

L. D. McKnight was one of the first African Americans hired as a deputy sheriff in Rutherford County. He is shown here sporting a fedora and posed in front of a car. Behind him to his left is a house that belonged to Dr. James Edward Jones, a local African American physician. The house on his right belonged to the Childress family. (Courtesy of James L. Butler Sr.)

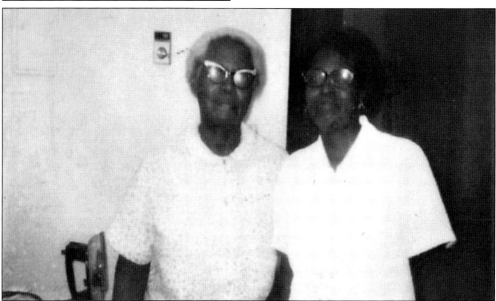

Annie Bell Spain Butler, the first wife of third-generation Century Farm owner Oscar A. Butler and mother of James L. Butler Sr., is shown here with her oldest daughter, Elizabeth. Elizabeth Butler attended Holloway High; however, she left to marry Vadie Woods. Vadie worked for a time as a dishwasher at a restaurant on the square called Mrs. Shipp's Coffee Shop. Annie Bell is said to have been a teacher in the Butler School that existed on Woodbury Road for a time. After her first marriage ended with Oscar, she moved her family to University Street in Murfreesboro and later to Nashville. She is buried in historic Benevolent Cemetery in Murfreesboro. (Courtesy of James L. Butler Sr.)

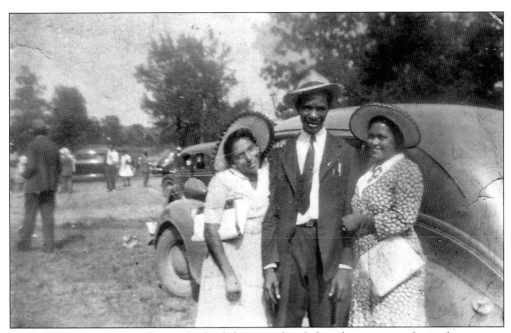

Decked out in hats, Sevier Garner Butler, left, is posed with friends on a sunny day in the country. (Courtesy of James L. Butler Sr.)

A young James L. and Dolores Butler family is posed here in the front yard of the home of Dolores's mother, Rose Williams McKnight, on Sevier Street. The family eventually expanded to seven girls and one boy. Butler was at one time a member of the E. A. Davis Elks Lodge, named after a former area African American physician, Eugene A. Davis. (Courtesy of James L. Butler Sr.)

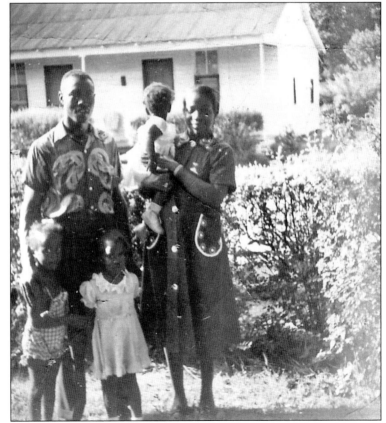

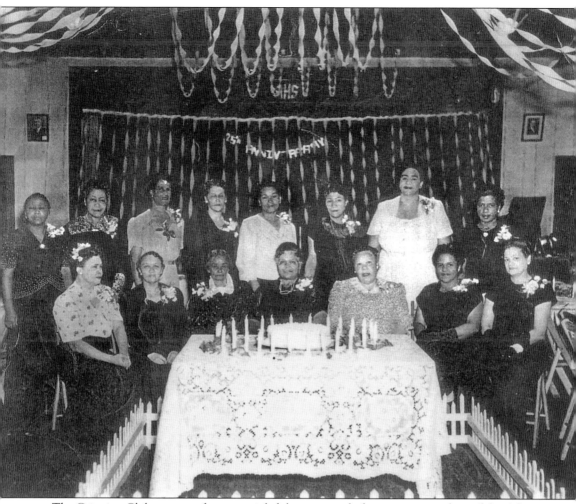

The Criterion Club was one of many social clubs composed of prominent members of the African American community of Rutherford County that thrived. Members include, from left to right, (seated) Jimmie Hickman, Willie Scales, Elma Williams, Bertha Green, Mattie Jordan, Inez Kersey, and Sadie Jones; (standing) Shelly Wade, Lillian Hammons, Picola Smith, ? Green, Buena Patterson, Ola Hutchings, Willie Avent, and Emma Rodgers. Sadie Jones, an educator, taught piano at the Mary Ellen Vaughn Training Institute. Willie Avent was a longtime active member of Key United Methodist Church and an employee of the Women's Club of Murfreesboro. She and her husband, Walter, lived on the corner of University and State Streets. Picola Smith was the first County Negro Schools supervisor, and Willie Burkeen Scales was the wife of H. Preston Scales and owner of a local mortuary founded in 1916. The Scales family owned a building on the "Mink Slide" area of the square in Murfreesboro. Area residents recall the poolroom operated there by Preston Scales, mortician and member of a local brass band, and Mrs. Rosa Kibble's restaurant. And on the Vine Street stretch of the "slide" were Dr. D. C. Hardin's medical office, Fred Malone's barbershop and Joe Nesbitt's barbershop. (Courtesy of Ernestine Tucker.)

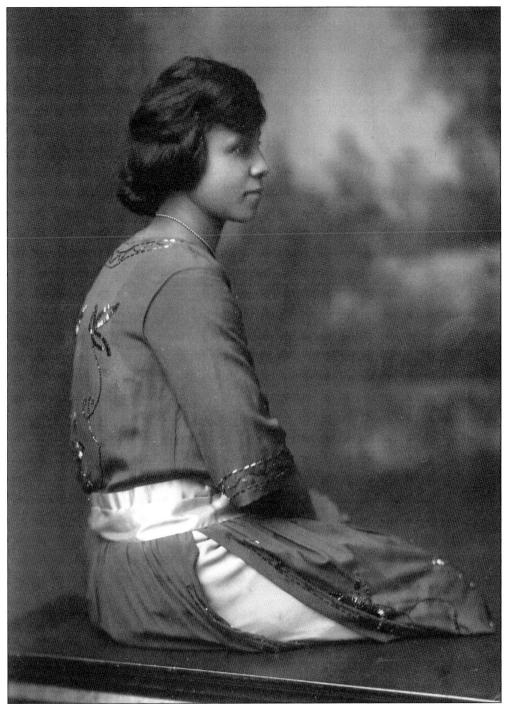

Dora Butler Proby, known for her beauty, was the daughter of Perry and Alice Henderson Butler. She was a domestic for the Todd family in Murfreesboro and married Louis Proby, who was employed by the family as well. They lived on Sevier Street in a yellow house with a basement, notes a former neighbor, a noted item because basements in houses were very scarce at that time. (Courtesy of James L. Butler Sr.)

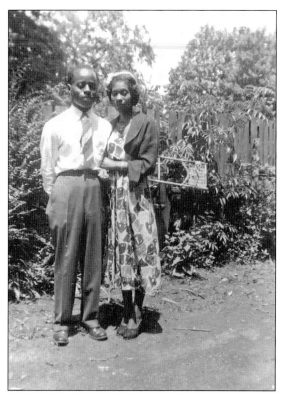

These lovebirds are Olivia "Stina" Murray and her husband, Collier Woods. Olivia Woods became one of the first African American students to graduate from Middle Tennessee State University in Murfreesboro. Her husband served in the navy and retired from the Rutherford County School System. Their entire family grew up as members of Allen Chapel African Methodist Episcopal Church in Murfreesboro. The family later moved to Mount Herman Road in Rutherford County. (Courtesy of Olivia Woods.)

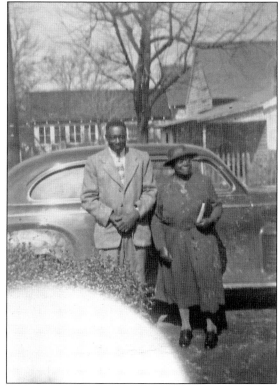

Liscus D. McKnight, former Rutherford County deputy sheriff, is shown here posed with his mother, Vella, in their Sunday best. Vella Mcknight lived on State Street. (Courtesy of James L. Butler Sr.)

Delores Jones is shown here posing for a photograph. Jones was a graduate of Holloway High who later moved away. Dolores Butler would speak of her as being one of her best friends in school. (Courtesy of James L. Butler Sr.)

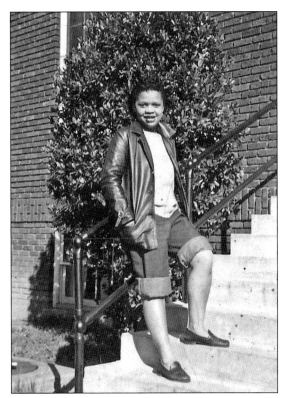

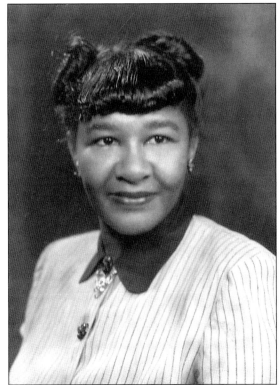

This is Ann McClellan, the daughter-in-law of Dr. John B. McClellan, a respected African American physician in the area. Dr. McClellan lived on the corner of State Street and Highland Avenue in Murfreesboro, and pictures show him with wild wavy hair. Ann is the mother of Charlie D. Childress. She was known fondly as "Cuttin Little Ann" by her cousin Dolores Williams Butler. (Courtesy of James L. Butler Sr.)

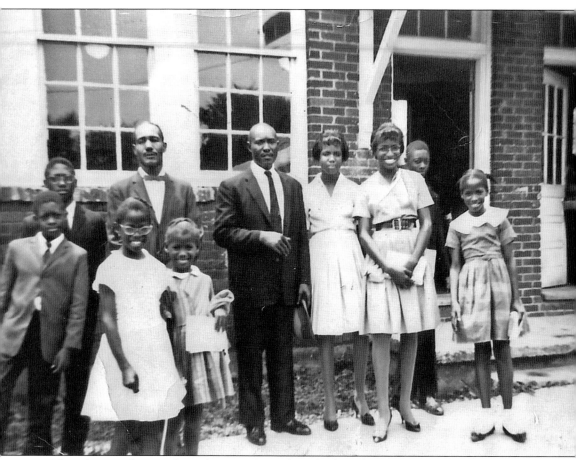

This photograph was taken when Key United Methodist Church, one of the original African American churches in Murfreesboro, was meeting at Holloway High School. The church caught fire at its College Street location. The cause of the fire was ruled electrical, although the actual source was never found. In this photograph, James L. Butler Sr. and his girls in their Sunday best pose after church service. The woman leaving the building is thought to be America Douglas, church member and a trained nurse. The gentleman in the bow tie is the Reverend John P. Willis, with the boys identified as the sons of the then pastor Rev. Paul Marchbanks Sr. The boys' names are Paul Jr., Silas, and Titus Marchbanks. Paul Jr. was the first African American to integrate Central High School. The church was rebuilt at its current location, 810 East State Street, in Murfreesboro. (Courtesy of James L. Butler Sr.)

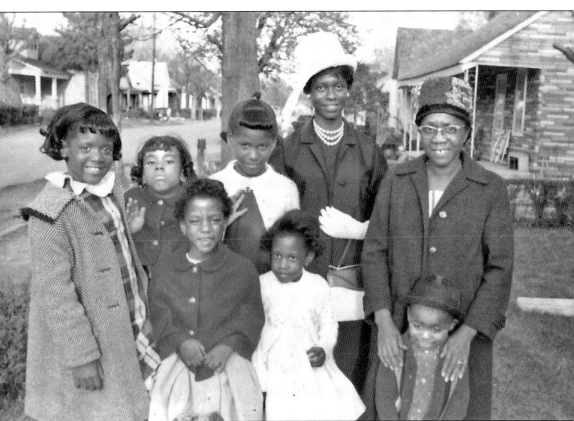

This lively group is posed in front of the home of Rose Williams McKnight on Sevier Street in Murfreesboro. Rose is here with two of her grandchildren, Euleda and James, as well as Gwendolyn McKnight and a group of other happy youngsters in their Sunday best. In the background on the right is a house owned by Molly Jones, an aunt of prominent Murfreesboro City Schools educator Myrtle Glanton Lord. Jones was a trained nurse and midwife who delivered many children in the area, including many of Rose's grandchildren. A young James, front right, recalls visiting the Princess Theater on Saturday mornings in the 1960s, with his sister, Euleda, when they showed cartoons. Other recollections of the Princess Theatre include one child viewing the movie *Ten Commandments* as well as Elvis Presley movies there. During segregation, African Americans were directed to sit in the balcony, nicknamed the "buzzard's nest"; however, when an African American movie was being shown, one theater patron recalls the entire theater was open for general seating. (Courtesy of James L. Butler Sr.)

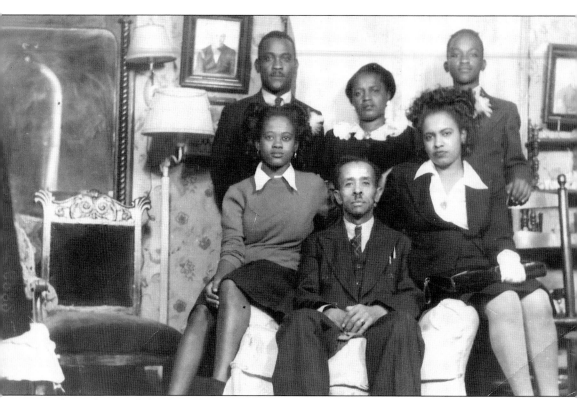

This is the Woods family in their home in the 400 block of Sevier Street in Murfreesboro. Notice the pictures hanging on the wall of the service members, with a young handsome Collier Woods Sr. on the left. George Woods, patriarch, sits center in the chair with his granddaughter Ramona Dunston Jennings on the left chair arm and his daughter Besse Woods Dunston seated next to him on the right chair arm. Standing are, from left to right, Jim Dunston Sr., Woods' son-in-law; his wife, Mary; and Jim Dunston Jr., his grandson. Mary Woods was a beautician and once operated the Glory hair salon from her home. (Courtesy of Olivia Woods.)

Born in 1849, Perry Butler was married to Alice Henderson Butler and set up home, according to census records, next door to his father, Joe Butler, and mother, Martha Lillard Butler, from New Orleans, Louisiana, on Woodbury Road in Rutherford County. Perry and Alice raised 10 children from this union. He founded Butler School and Church on the property and had several of his children teach in the school. Minister Robert "Weedmule" Price would speak of having been taught there. Perry died in 1920 and was buried in the Butler Family Cemetery. (Courtesy of James L. Butler Sr.)

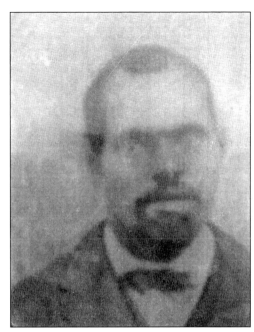

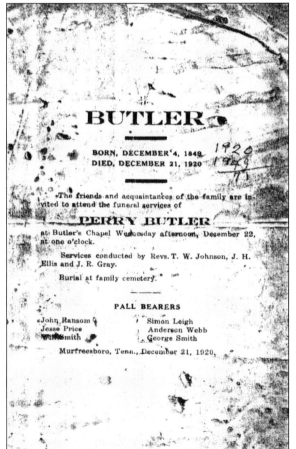

This is a copy of the invitation to the funeral of Perry Butler at the Butler Family Church in 1920. Perry was a second-generation owner of the 2008-designated Butler Century Farm. One of the conductors of the service was Rev. J. R. Gray, who was the namesake of Gray's Chapel United Methodist Church, an African American church located in the Dilton area of Rutherford County. Butler Chapel had an African Methodist Episcopal affiliation. Butler Chapel met the second and fourth Sundays and had Sunday school weekly. (Courtesy of James L. Butler Sr.)

Sylvia and Gwen McKnight, daughters of L. D. McKnight, are posed for a photograph. Younger sister Sylvia's nickname was "Babysis." (Courtesy of James L. Butler Sr.)

Gwendolyn McKnight, daughter of African American deputy sheriff L. D. McKnight, is posed for a photograph. L. D. was in the first graduation class of old Holloway High. (Courtesy of James L. Butler Sr.)

A young Stina Murray Woods, as a Tennessee State University student, is posed for a picture. She depicts a beaming and vibrant personality and smile that still holds true today. She was a member of several clubs in town, including the Better Home and Gardens Club and the Dynamic Club. (Courtesy of Olivia Woods.)

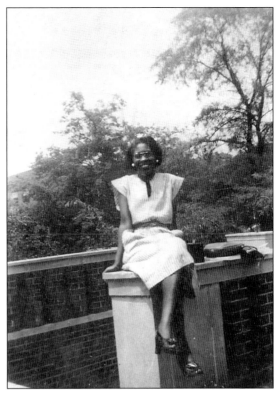

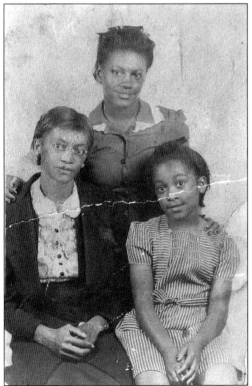

A young Georgia Lee Smith (center) is posed with her cousin Hattie Mae Smith and Mary Irene, Hattie's grandmother. Robert Avant, a World War I veteran, is the brother of Mary Irene. He served with the American Expeditionary Forces in France from August 30, 1918, until June 23, 1919. Georgia Smith was a member of Key United Methodist Church, where she served as a member of the choir and the United Methodist Women. (Courtesy of Mary Anne Smith.)

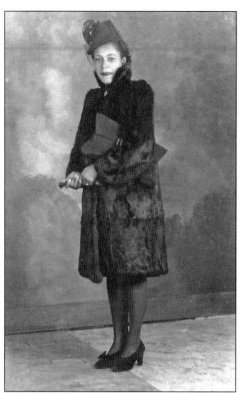

Annie Lou Cowan Donnell Thornton, sister of Agnes Howse, is dressed up in the most fashionable fur coat of the day. Charlie, the son of Agnes Howse and Charles Sr., owned an African American dry cleaning business in town. Charles Jr. married Mary Howse, a former student of the Lilliard School in Rutherford County and a member of Key United Methodist Church. When he began his dry cleaning business, one area resident recalls, he would go from door to door asking if his services were needed. (Courtesy of James L. Butler Sr.)

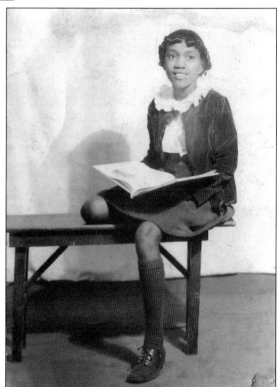

A young and bright-eyed Juanita Donnell, daughter of Annie Lou Cowan Donnell, is shown here in her school photograph. (Courtesy of James L. Butler Sr.)

James L. Butler Sr., the youngest son of Oscar Alfonzo Butler, is seen as a boy in his best posed for the camera. Later "Link" Butler, as he is called, was to become a leader in the Murfreesboro community as the Worshipful Master of Murfreesboro Lodge No. 12, a 33rd-Degree Mason, and commander of the local Veterans of Foreign Wars post. (Courtesy of James L. Butler Sr.)

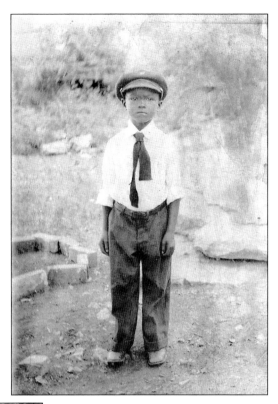

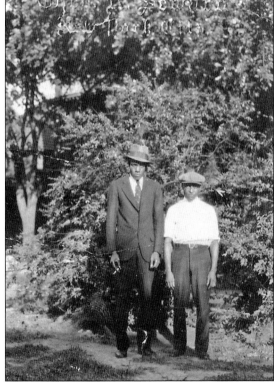

Berry Richmond Seward (left), a World War I veteran and Purple Heart recipient, stands with an unidentified person. He made only one visit to Rutherford County after serving in France. He attended Tennessee A&I in Nashville for veterinary medicine. His niece recalls that he was an avid reader and worked for several auto manufacturing companies in Detroit, Michigan. (Courtesy of Ernestine Tucker.)

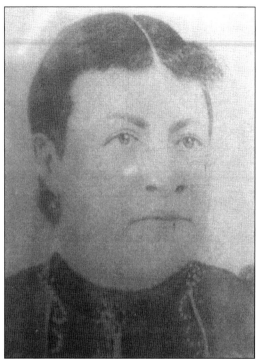

Alice Henderson Butler was the daughter of Isaac and Lavenia Henderson, both slaves traced to a former Rutherford County judge in the 1820s. The Judge Logan Henderson home, now called Farmington, still stands today on the old Manchester Pike. Alice, born in 1852, later married Perry Butler and set up home on Woodbury Pike, now Highway 70. After the death of her husband, Alice moved to town and lived on 214 University Street until her death in 1939. Her last will and testament denotes prominent white attorney Granville S. Ridley as her lawyer. The two families were very close, with Butler family members recalling the Ridley family visiting and touring the Butler property upon occasion. Alice's daughter, Cordelia Butler Early, is named in her will as executrix. "Delia," as she was called, served as an educator at Cemetery School in Rutherford County. (Courtesy of James L. Butler Sr.)

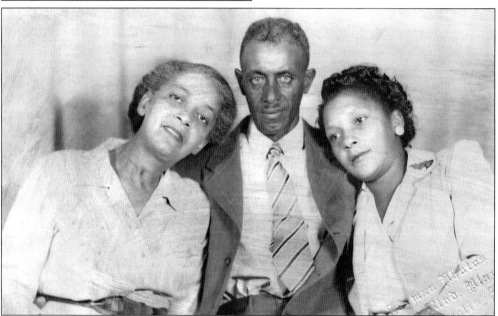

Shown here with his sister Lucille (left) and his fourth wife, Sevier Garner, Oscar A. Butler poses for a picture. Lucille Butler Jarman, a former teacher at Butler School as well as Cemetery School, later moved to Indianapolis, Indiana, where she was a teacher as well. She married a photographer, Jesse Jarman, who would upon visiting the area take photographs of people in the area, thus providing some with the only professional family photographs possessed at the time. When Oscar would visit his sister in Indiana, he would sit for a photograph session there as well. (Courtesy of James L. Butler Sr.)

Mildred Black Sublett, second from the right, was the wife of Ben Sublett. She is posed here with unidentified others. The couple at one time resided on Sunset Street in Murfreesboro. (Courtesy of James L. Butler Sr.)

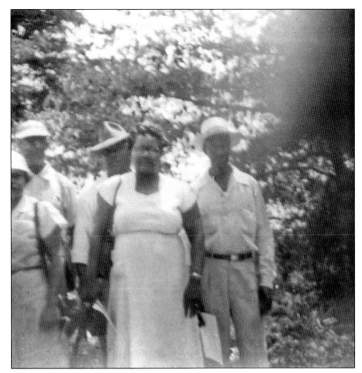

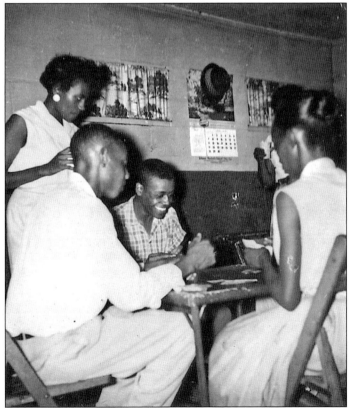

This July 1959 photograph shows a young Georgia Lee Smith (standing) watching a rather exciting card game between Charlie D. Childress and Hubert Robinson; the lady to the right is unidentified. (Courtesy of Mary Anne Smith.)

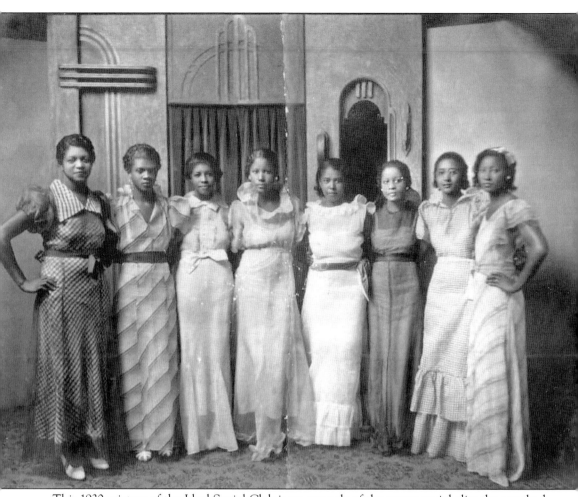

This 1930s picture of the Ideal Social Club is an example of the young social elite the area had to offer. From left to right, the members are Louise Officer, Andrewine Seward, Nannie George Smith Rucker, Lena Jarrett, Lydia Jackson Glanton, Annie Mae Jarrett "Muncie" Freeman, Hattie Johnson, and Annie B. Johnson. Annie Freeman worked at one time for Dr. J. R. Patterson in his local practice. Nannie George Smith Rucker was a longtime educator with the Rutherford County School System. She taught at Emery School and later became principal of the African American Shiloh School. In 1969, she became the first African American educator to teach at Homer Pittard Campus School, a teacher training school affiliated with Middle Tennessee State University in Murfreesboro. Prior to that, however, a career high was when on April 21, 1947, upon the recommendation of the county school superintendent, Nannie G. Rucker was chosen to appear before a committee in Washington, D.C., along with two others to testify before a U.S. Senate Subcommittee of the Labor and Public Welfare Committee. These top educators from one-room schoolhouses testified to the need of a $250,000 grant to improve state educational facilities. Rucker made national and international press with the appearance and even was heralded with "Nannie Rucker Day" in Doylestown. Rucker was also a 1972 delegate to the Democratic National Convention. Andrewine Seward is noted as teaching at several African American Rutherford County schools, including Happy Hill. Lydia Jackson married area resident Simon Glanton, insurance agent and later store owner. She is listed as having taught at Bethel School, Overall School, Brown School, and others in Rutherford County. (Courtesy of Ernestine Tucker.)

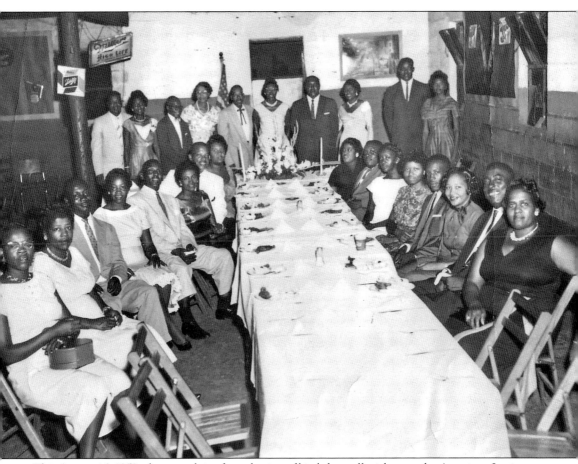

This August 16, 1959, photograph is of a gathering of birthday well-wishers at the American Legion Hall on Ash Street in Murfreesboro. The honoree and attendees, identified by a fashionable and present Grace Turner, include, (left side of table) Crick Odom, Hamp Turner, Grace Turner (fourth from the front), Frank Strickland, Georgia Smith, ? Newman, and Cora Newman; (standing) Peanut Jarrett, Lena Jarrett, Ewell Willis, Jesse Mae Willis, Will A. McGowan, Pauline McGowan (the birthday honoree), an unidentified couple, Frank Gaines, and Josephine Gaines; (right side of the table) Elizabeth Jacoway, Charles ?, Myrtle Hazel Simmons, Hamp Johns, Loretta Johns, Sis Johns, Junior Roper, and Dorothy Rucker. Veteran Ewell Willis had a shoe shine business on the square, as well as being credited with integrating the lunch counters downtown, and is said to have suffered threatening phone calls and boycotts by white customers. After losing the use of his vocal chords, he assisted others with their transition with their medical condition, recalls one local resident. He served as president of the Lost Chord Association of Middle Tennessee. He and his wife, Jesse Mae, sister to Willie Avent, were lifelong members of Key United Methodist Church and served in many capacities. He was president of the local NAACP from 1946 to 1957 as well. The sisters were members of the nurse's aide society, the Gray Ladies, which worked at the V.A. Hospital in Murfreesboro. (Courtesy of Mary Anne Smith.)

This is a copy of the original deed showing that Joseph Butler, a colored man, with a white cosigner, paid $5,000 for 67 acres of land located in Rutherford County. That property is still in the family today. Joe Butler was born in 1822 and died in Rutherford County in 1897. It is said that he and his brother John Butler arrived in Rutherford County, free papers in hand. John married a woman named Millie Alfred, and Rutherford County Schools records show a John Butler family on the roster of the old African American St. Paul's School. Joe Butler purchased property for a family graveyard in 1889 and is buried there beside his wife, Martha Lillard. (Courtesy author's collection.)

L. D. McKnight, former county sheriff's deputy, strikes a casual pose on a flight of steps. Rutherford County resident Houston Overton recalls passing the football with him on the sidelines during games. (Courtesy of James L. Butler Sr.)

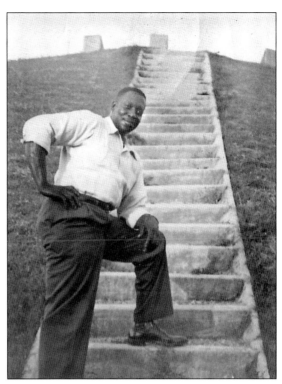

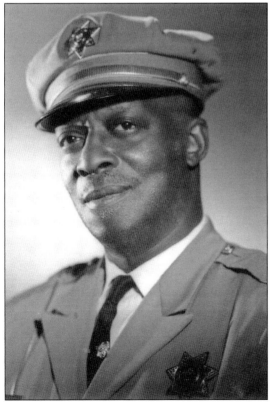

Liscus D. McKnight was one of the first African Americans hired as a deputy by the Rutherford County Sheriff's Department. He is shown here in uniform in the 1960s. He lived on Sevier Street in Murfreesboro and later married Rose Williams McKnight. (Courtesy of Denese Artis.)

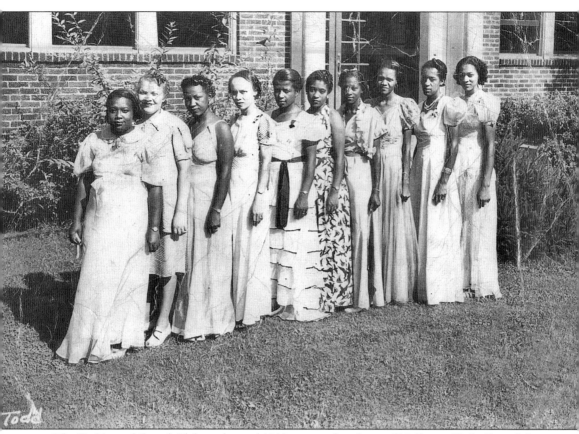

The Be Natural Social Club in the mid-1940s is posed in front of Holloway High. From left to right are (followed by their husbands' names) Genivive Butler (Horace), Elizabeth Willis (John P.), Mattie B. James, Rosa Glanton (James), advisor Emma G. Rogers-Roberts, Olivia Woods (Collier), Lalia Zachery (William), Mattie Rabon Butler (William), Annie Bell James, and Alean Rucker (Howard). Emma G. Roberts began teaching in 1936. In 1953, she assumed responsibilities as building principal in the old Bradley School on Academy Street. She was a charter member of the Beta Epsilon Chapter of Delta Kappa Gamma Society International, a professional organization devoted to honoring and advancing outstanding educators. She was a charter member of the Better Homes and Gardens Club and the first African American principal in the Murfreesboro City Schools. She became the first African American teacher inducted into the Tennessee Teachers Hall of Fame. (Courtesy of Mattie Butler.)

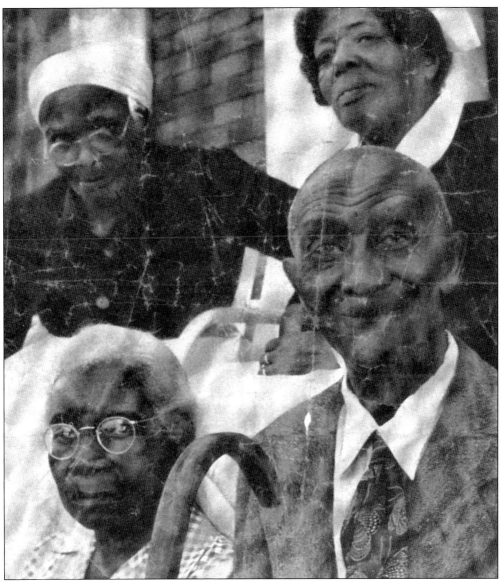

Gen. Douglas McArthur visited Murfreesboro on his 14th wedding anniversary. Thus, on April 30, 1951, his wife, Jean Faircloth McArthur, who called Murfreesboro home, was greeted by many well-wishers. It was the largest crowd the town square had ever witnessed. This photograph was clipped from the original May 14, 1951, article of *Life* magazine that covered the event and was given to Ernestine Burris Tucker, the niece of Will Seward, for her records. These African Americans were her former domestic staff who were gathered to greet Faircloth upon her return visit with her famous husband. At left in the back row is Matilda Avent, cook, and to her right is Mary Ellen Vaughn, an educated woman who went to school in Alabama and started a night school for adults, was a local newspaper editor, and among other honorable deeds, served as the personal nurse of Faircloth. Lillie Cheers, housekeeper, is seated left front next to Will Seward, the gardener for Faircloth, when she lived in Murfreesboro. (Courtesy of Ernestine Tucker.)

Former slave Berry Wesley Seward is photographed here with his youngest daughter, Andrewine Seward. Berry was a member of the precursor to Key United Methodist Church from its beginnings on College Street, where he served as a steward, cleaned the church, set out communion, and was a greeter at the welcome table. According to his granddaughter, he was also known for his lengthy but heartfelt prayers commented upon by young girls Christine Miller and America Douglas. "Uncle Berry," as he was known, was one of the area's first skilled electricians. He is noted in one Murfreesboro history source as being a "colored factolum" of John Nelson, who was the son of Dr. J. H. Nelson, owner of the electric plant at the time. Seward was able to obtain a position with Murfreesboro Power Department in later years and in turn was one of the few African Americans in the area receiving a pension prior to his death. Andrewine Seward, according to Rutherford County school records, was an educator in several schools, including the African American Little Hope School. The Seward family is buried in Benevolent Cemetery in Murfreesboro. (Courtesy of Ernestine Tucker.)

This is an unidentified woman posed outside.
(Courtesy of James L. Butler Sr.)

Oscar and Sevier Butler are pictured by their car
in the Woodbury Pike rock quarry. With his fourth
wife, Sevier Butler, Oscar was the third owner of the
Butler Century Farm, founded in 1880 on Woodbury
Road. During the construction and paving of the
road, known as Highway 70, two rock quarries were
constructed on the property to meet the needs of the
road construction. The quarries were later filled in
during the 1990s by the farm's current owner, James
L. Butler Sr. (Courtesy of James L. Butler Sr.)

A young Fruzzie Burris is pictured here. Notice her dress and shoes, indicative and characteristic of the 1920s and 1930s. She was a teacher for many years in Rutherford County in schools including Dilliard and Bethel. She was a member of Mount Zion Primitive Baptist Church. She went on to marry Jack Foster. (Courtesy of Ernestine Tucker.)

A young Fruzzie Burris and T. Roosevelt Seward hold hands amid a nature backdrop, somewhere near Stones River. The cedar trees and the rocks are characteristic of this area. Although local sweethearts, they never married. The inscription on this photograph—"Upon This Rock I'll Build My College"—gives one an idea of the big dreams that he had for the future. The two did not marry, with Seward choosing to settle in the North. (Courtesy of Ernestine Tucker.)

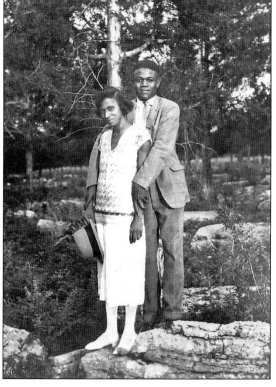

Rose Williams McKnight (some called her "Rosena") has her hand on her hip and is caught with eyes closed for this flash. It is recalled by old friends that she loved the pose. (Courtesy of James L. Butler Sr.)

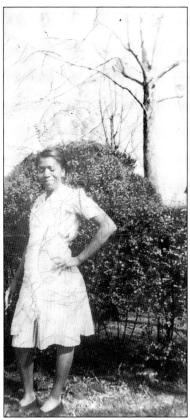

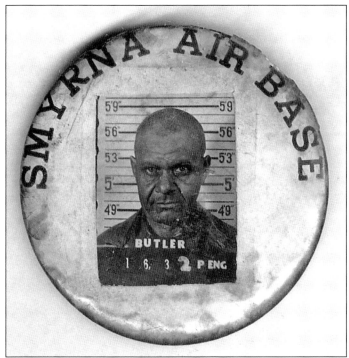

Isaac "Ike" Butler was an employee of the Sewart Air Force Base in Smyrna, Tennessee, located in Rutherford County. The base was in operation from 1941 to 1971. This is his identification badge. He is a brother of Oscar A. Butler and the son of Perry Butler of Rutherford County. (Courtesy of James L. Butler Sr.)

Ella Proby, second wife of Louis Proby, is cheerfully talking with Dolores Williams Butler. "Miss Ella" lived across the street from Dolores's mother, Rose, on Sevier Street in Murfreesboro and was a great neighbor with an open door. (Courtesy of James L. Butler Sr.)

A young bright Theodore Roosevelt Seward, nicknamed "Bus" by friends, is posed in his suit and dress coat befitting the look of his New York relocation. This Rutherford County native actually placed a name stamp on all of his photographs, giving an indication of his attention to detail and his drive for excellence. His niece, Ernestine Tucker, still possesses many of his personal items, including the camera with which this photograph was taken. He would state the camera, still in excellent condition today, was purchased two years before she was born. (Courtesy of Ernestine Tucker.)

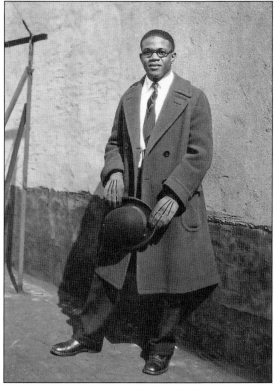

The photograph to the left is suspected to be of Mary Irene Smith, a resident of Rutherford County. The woman holding a baby is unidentified. The lady is thought to be the mother of Mary Irene Smith and great-grandmother of Hattie Mae Smith, Rutherford native. (Both courtesy of Mary Anne Smith.)

Rose Williams, daughter of Rose P. Overall, was a lifelong resident of Sevier Street in Murfreesboro. A devoted mother and grandmother, she is shown here with two of her eventual eight grandchildren, who lovingly referred to her as "Nanny." The photograph was taken in the back of her home. (Courtesy of James L. Butler Sr.)

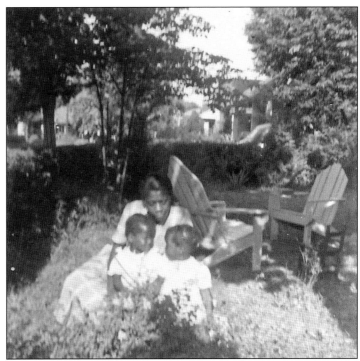

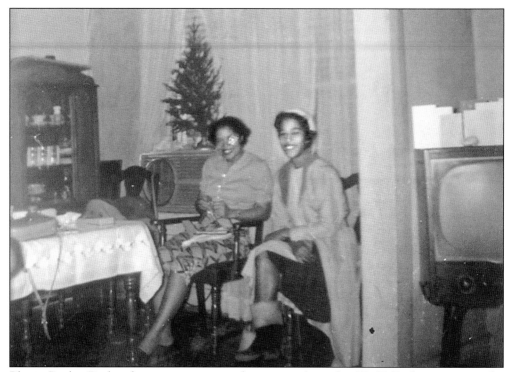

Blossie Rucker Butler, the woman wearing glasses, was the wife of R. T. Butler, a nurse at the Alvin C. York Veteran's Hospital in Murfreesboro and a former student of the old Cemetery School. She is posing in this February 1961 photograph with a young Dr. Jacqueline E. Wade. Wade was born and reared in Murfreesboro and is a graduate of Holloway High. She is the daughter of Ellen Doris Foster Wade and Aaron D. Wade. Dr. Wade received her bachelor of arts degree from Fisk University and has a Ph.D. in education and a master of social work from the University of Pennsylvania. She is employed at Middle Tennessee State University. (Courtesy of Olivia Woods.)

This June 1962 picture is of a young Collier Woods Jr. playing in the vicinity of where he used to live, on the corner of Mercury and Carver Streets in Murfreesboro. Johnson Street and that area used to flood after heavy rains for quite some time. The flooding was later mitigated, but it made for quite a scene for Mercury Boulevard neighbors, as well as quite a dilemma for the inhabitants. (Courtesy of Olivia Woods.)

Dolores Williams Butler was a native of Rutherford County and grew up on Sevier Street in Murfreesboro. She attended Bradley Academy and graduated from Holloway High School. Although a homemaker and mother of eight children for much of her life, she worked for a time for the Waller family of Murfreesboro. She also was an employee of Dr. Shacklett in his Murfreesboro medical office. (Courtesy of James L. Butler Sr.)

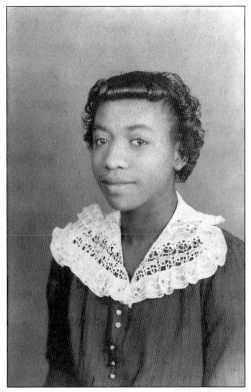

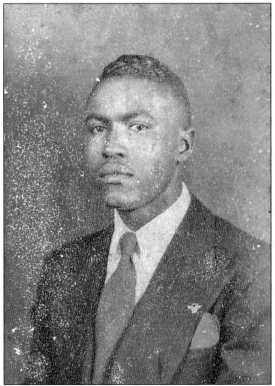

James L. Butler Sr., sometimes known as "Link" Butler, after serving in the navy during World War II retired from the local General Electric plant. He was initially hired as a janitor because African American Americans were not to be hired as plant workers at the time. He credits vocal advocates such as Dr. James Patterson for working for equal employment rights locally. The janitors at the General Electric plant were given a closet as an office. They jokingly referred to it as "the crows nest." He then moved up to be one of the first African Americans to work at the Murfreesboro plant. He went on to start the Butler Angus Farm on the family property in the early 1990s. He is now retired. (Courtesy of James L. Butler Sr.)

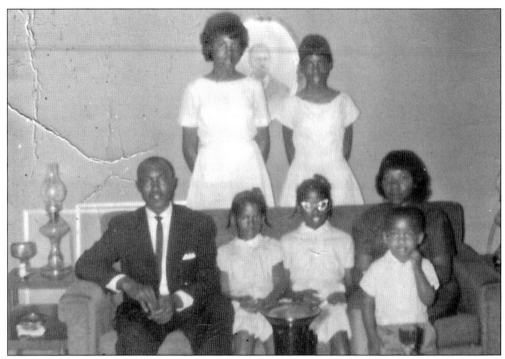

This early 1960s photograph of the James and Dolores Butler family shows the group in their Sunday best posed with a picture of second-generation Tennessee Century Farm owner Perry Butler on the wall behind them. The family was a member of Key United Methodist Church in Murfreesboro, where James Sr. served as a lay leader as well as in many other roles throughout the years. The daughter standing behind on the left, Emily, went on to be the first African American in the Central High School Professional Secretaries Club. She graduated from Middle Tennessee State University. On the right is Denese, who moved to Orangeburg, South Carolina, and attended South Carolina State College. She was the first African American to work in the courthouse there. Euleda, also pictured here, graduated from Bradley Kindergarten and was in the first class to graduate from the integrated Oakland High School in Murfreesboro. After graduating, she began to work for the FBI in Washington, D.C. She met and married Gambian native Sheikh T. Faye, former Olympic track athlete and Middle Tennessee State University Hall of Famer. The two have retired and bought a home and business in Banjul, Gambia. (Courtesy of James L. Butler Sr.)

Folks enjoy an early morning dip into the Stones River during a "gypsy" breakfast. A young Deborah Woods, daughter of Olivia and Collier Woods Sr., is in someone's arms, while another participant standing is Georgina Alexander. The others are unidentified. (Courtesy of Olivia Woods.)

This woman, Lady Bertha Williams, wearing large pearls is an aunt of Dolores Williams Butler. (Courtesy of James L. Butler Sr.)

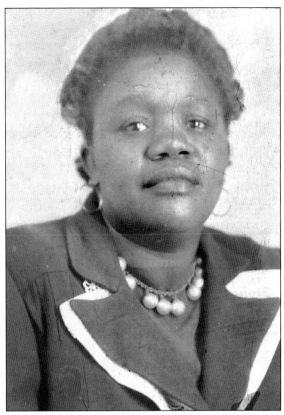

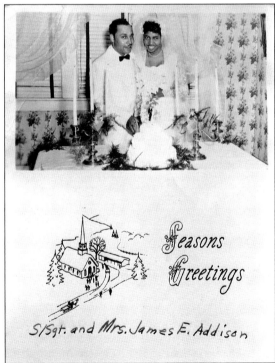

Rutherford County native Cora Hutchings married S.Sgt. James E. Addison and sent out this photograph as a Christmas greeting. Cora, a graduate of Holloway High School, was the daughter of highly respected educator Ola Bell Hutchings. Cora and James had two children. Cora was a respected educator in her own right and retired from the Rutherford County School System. A woman very active in First Baptist Church, she was also a longtime member of Alpha Kappa Alpha Sorority, Inc., and the Rutherford County Education Association. (Courtesy of Olivia Woods.)

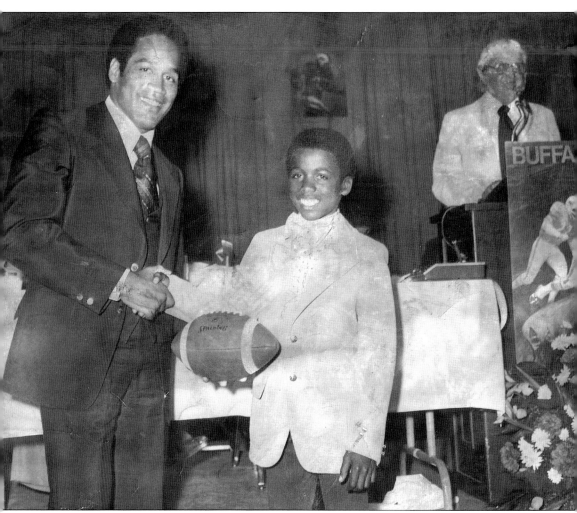

Before the Nicole Simpson murder trial and Las Vegas hotel room confrontations, O. J. Simpson was a record-setting player for the Buffalo Bills football team in the National Football League. Here at a Murphy Center banquet, a young grade-school-aged James L. Butler Jr. is smiling at the presentation of his signed football by Simpson, also known as the "Juice." Rutherford County natives who became professional football athletes include Dennis Harrison, with the Philadelphia Eagles and the Los Angeles Rams; Robert James, a Buffalo Bills player; Melvin Daniels, who played for the Detroit Lions, the Cleveland Browns, and the World Football League; and the local Methodist minister and high school vice principal who brought Simpson to town for the occasion, Robert James. James L. Butler Jr. is now a United Methodist Church minister serving at Elder's Chapel United Methodist Church in Rutherford County. The church is over 100 years old. (Courtesy of James L. Butler Jr.)

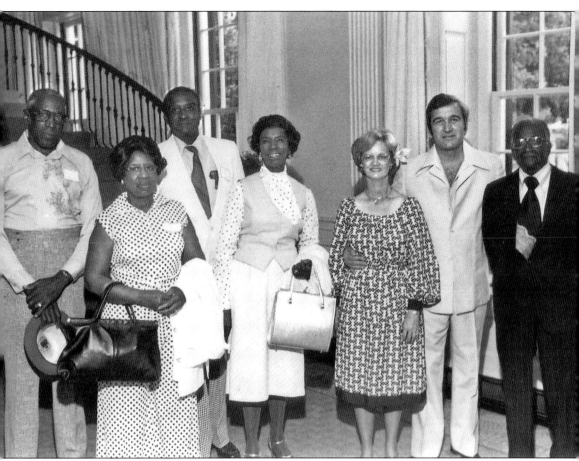

Dora Robinson Rucker is shown here second from the left with her husband, Chester (to her right), and her sister-in-law, Nannie George Flowers Rucker, and her husband, James. They are posed for a picture at the Tennessee Governor's Mansion in Nashville, with then governor Ray Blanton and his wife, Betty. To the governor's right stands Booker T. Washington. Washington, as Dora Rucker recalls, was employed as a chauffeur in Rutherford County. Dora Rucker is still very politically active, having served 14 years on the Rutherford County Election Commission, and has been awarded numerous resolutions supporting her career and efforts from several governors and legislators, including a 2009 "Long Haul" award from the Tennessee Alliance for Progress. Rucker now lives on Johnson Street in Murfreesboro. (Courtesy of Dora Rucker.)

Dorothy Johnson Malone has been a member of Elders Chapel United Methodist Church for over 30 years. This picture was taken when she was in the ninth grade, accompanying her younger sister, Mary Jane, on a field trip with Locke School to Look Out Mountain, Tennessee. Several years ago, Dorothy Malone organized the first ever elementary school class reunion for Locke School in Murfreesboro. The successful event was done with other former students J. D. Spann and Dorothy's sister, Mary Jane Johnson. Dorothy Johnson married fellow Holloway High graduate William Lus Malone. They live on Enon Springs Road in Rutherford County. (Courtesy of Dorothy Malone.)

This photograph taken in September 1958 is of Houston Overton Sr. and his son Houston Jr. posed upon a horse. Houston Overton retired after 27 years as a postal worker. He married fellow class of 1945 Holloway High classmate Ella Jane Brandon. They still reside in Rutherford County. (Courtesy of Houston Overton.)

Collier Woods Jr. is a native of Rutherford County who has worked as a lighting designer and technician for over 20 years and has traveled the world. He has worked for the Alvin Ailey Dance Troupe, The Dance Theatre of Harlem, and the Pacific Northwest Ballet among others. He has traveled with many shows, including *Showboat* and *The Color Purple*. He is married and lives in Florida, still working in the theater. (Courtesy of Olivia Woods.)

MINNEAPOLIS, MINNESOTA
The magnificent skyline and an excursion boat on the Mississippi River bespeak of the dynamic but gentle nature of this unique city.

post card

Hi!
Cold, flat and windy is the best way to describe Minneapolis/St. Paul. By the time you get this we may be gone back to seattle. I hope all is well. See you!

Collier

TO: DEVORA BUTLER
2021 4TH AVE.
SEATTLE, WA 98121

© Cartwheel Co. — 182 State St. — P.O. Box 7370 — St. Paul, MN 55101 USA
Printed in Australia by Colorscans

© Photo by Mark Fay

While living in Seattle, Washington, Collier Woods Jr., prominent lighting designer, technician, and Rutherford County native, sent this postcard to Devora Butler. Butler, also a Rutherford County native, was living in Seattle, working on staff for the Seattle area U.S. congressman. This postcard was sent while Woods was on the road with a show in Minnesota in 1989. Collier's buoyant and beaming personality makes him a natural for the theater. (Courtesy author's collection.)

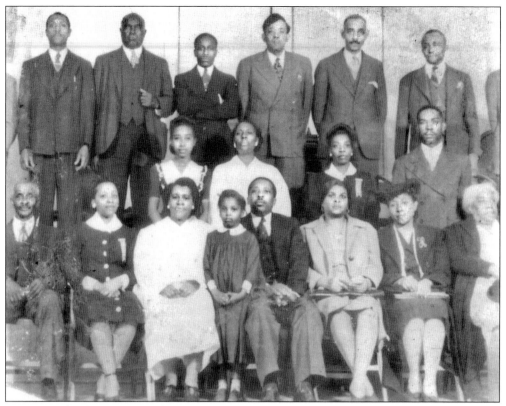

Preston Scales (standing fourth from the left) poses at First Baptist Church. A young Ella Jane Overton sits at far left in the second row, next to the mother of Houston Overton, Tennie Pauline, in this picture. Others identified in this photograph include Rev. William Donaldson, Georgella Washington, Booker T. Washington, Luther T. Glanton Sr., and Richard North, standing middle row right. Glanton Sr. is the father of Luther T. Ganton Jr., Myrtle Glanton Lord, and Simon Glanton. Glanton Jr. was the first African American attorney in Murfreesboro and went on to practice law and become a judge in Iowa. (Courtesy of Houston Overton.)

This man is strutting down a city street with a hat display in the storefront. (Courtesy of James L. Butler Sr.)

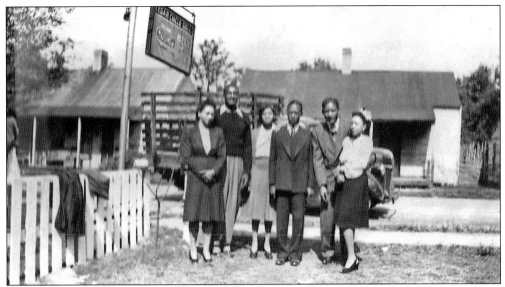

Pictured across the street from the Cedar Circle Grill, owner John Henry Burrus poses with his second wife, Lura (far left); James Rucker, his nephew, at his left; sister Minerva Staples (center); and his niece, Alean Wade (far right). (Courtesy of Ernestine Tucker.)

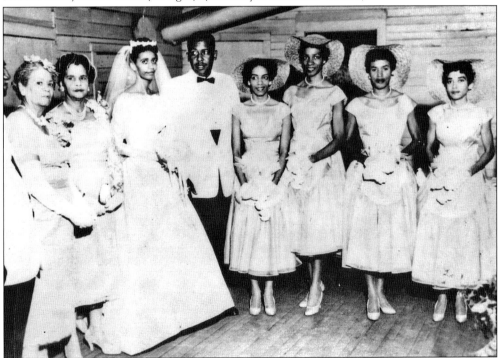

The Peters wedding party is pictured here as local Elma Jones married a Mr. Peters. The wedding party has local Hilda Belle Willis (third from the right) as a bridesmaid, and the rest of the bridesmaids are unidentified. The man at the far left is the bride's father, Dr. James E. Jones, a local physician, beside his wife, Sadie, and her sister Elma, for whom young Elma was named. Dr. Jones graduated from Meharry Medical College in 1926 and began practicing in Murfreesboro shortly thereafter. (Courtesy of Houston Overton.)

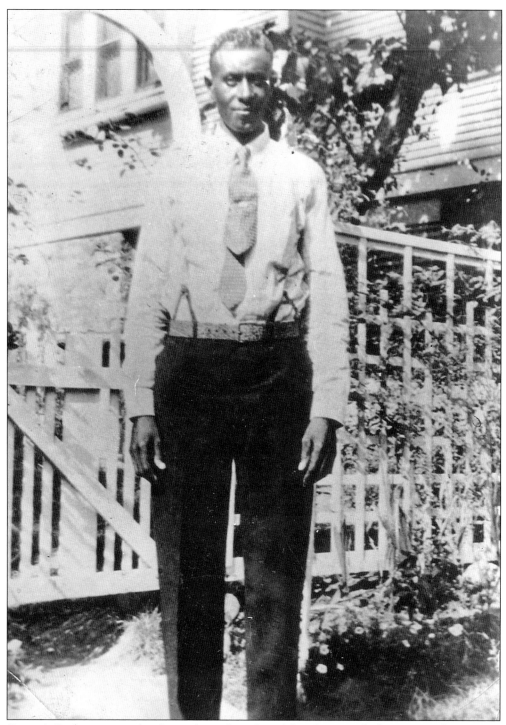

Oscar A. Butler is pictured in front of a garden arbor. A handsome, tall, thin man with gray eyes, Butler was known to be quite a charmer. He was a farmer and also managed a baseball team in his time in the Dilton area. His son James recalls that the team played Mount Pleasant and Halls Hills and was very good. (Courtesy of James L. Butler Sr.)

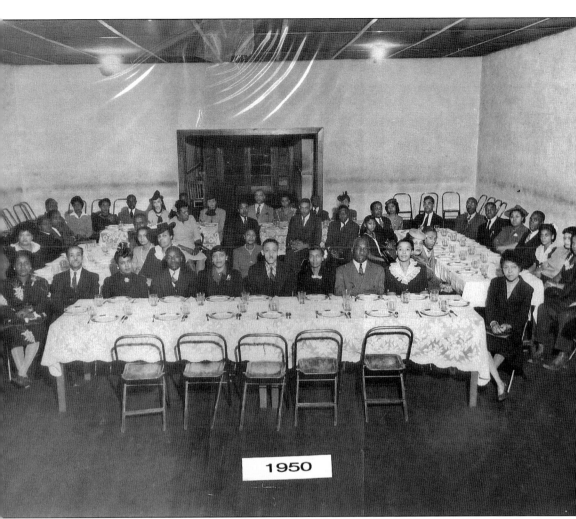

This is a 1950 photograph of an event held at old Holloway High School. Included, in no particular order, are George and Mary Woods, Bessie Dunston, Booker T. Washington and his wife, Georgella, Ella Burris, Howard Moore, Mary D. Moore, Odie Rabon, Lucy Rabon, Luther Glanton Sr., Benjamin Francis, Collier Woods Sr., Shelley Gaines, James Glanton, Rosa Glanton, Charlie Howse, Agnes Howse, Willie Gaines, Alma P. Murray, Mattie Murray, Reverend Donaldson, Mrs. Murray, L. C. Finch, Mr. Williams, an insurance agent, Willie King, Inez Smith, Ruby Jones, Robert Rucker, Tommy "Slim" Franklin, and James and Florence Krauss. An observer noted that the chairs had no backs and were issued there when the school was built. Not only did African American schools receive used textbooks but also lesser funding than their white counterparts. (Courtesy of Houston Overton.)

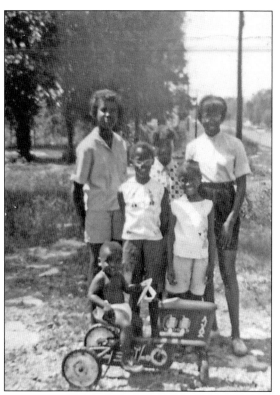

These children are posed in front of Highway 70, also known as Woodbury Pike in Rutherford County. The gravel used to pave the road was taken from two quarries located on their property. These children of James L. and Dolores Butler went on to graduate from high school, marry, and become mothers and fathers in their own right. The oldest, Donna Elaine (back right), went on to have the first wedding held at Key Church on State Street and to move to Texas and be voted teacher of the year three times. She is an author and made the local bestseller top 10 in Galveston, Texas, for several weeks with a book of poetry. She married John Warren, had two daughters, and is now retired and living in Texas City. (Courtesy of James L. Butler Sr.)

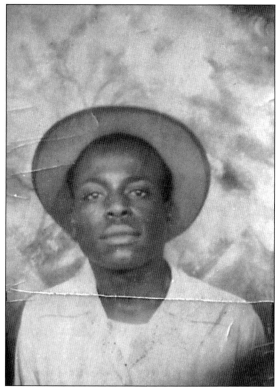

This is an unidentified young man in a hat. (Courtesy of James L. Butler Sr.)

Thenartis Ellis, a Rutherford County native, is the first African American secretary of a department at Middle Tennessee State University. In addition, while a student at Tennessee State University in Nashville, she was a member of the famed Tigerbelles track team. During the 1957–1958 track season, she was on the team that traveled from Nashville to New Jersey for the Olympic trials, but she was unable to qualify. Her teammate Wilma Rudolph did, however, and went on to win a gold medal for the United States in the 1960 Olympics in Rome, Italy. (Courtesy of Thenartis Ellis.)

Jesse Ellis was married to Thenartis Ellis of Murfreesboro. He was one of the first African American firemen in the city and captain in the Murfreesboro Fire Department. (Courtesy of Thenartis Ellis.)

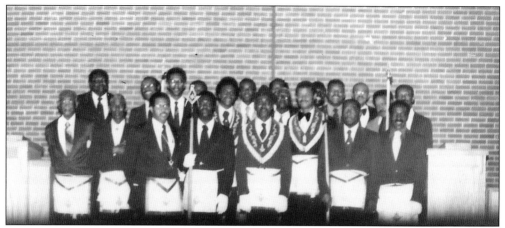

This is a picture of Murfreesboro Lodge No. 12 taken in the sanctuary of Key United Methodist Church on East State Street. Front and center in the hat is James L. Butler Sr., the Worshipful Master, with other members including Walter Avent (front left), husband of Willie Avent of Key Church, and R. T. Butler (third from right in back in glasses), former educator and 33rd-Degree Mason. (Courtesy of James L. Butler Sr.)

Clarence Crockett was one of the members of Murfreesboro Lodge No.12 who reactivated the group in 1946 after a lapse. Pictured here with a fellow Shriner and lodge member James L. Butler Sr., Clarence Crockett and those lodge members who worked to reactivate the lodge were Clifton E. Black, Martin H. Benford, Mose Sims, Robert Smith, Sam Avent, and Henry Davis. A longtime lodge member, Crockett lived only a few houses down from the hall on Hancock Street. He was married to Sallie Mae Crockett, who. according to the 1949 edition of the *Mid-State Fair News*, served as superintendent of the Women's Department and its displays. Clarence Crocket retired from the railroad. (Courtesy of James L. Butler Sr.)

A Holloway High School Red and Black reunion is celebrated at the E. A. Davis Elks Lodge 1138 in Murfreesboro. The Elk's Club, as it is called, at one time was located on old Nashville Highway. That facility burned down in the 1970s. They would have bingo there, with Hamp Swafford calling the numbers. All would revel at his technique, calling "under the Bee, toodie too . . . Bee too-too!" The club was later rebuilt on Halls Hill Pike, where it stands today. This photograph shows former Bradley teacher Myrtle Glanton Lord on stage (far left) with former educators Susie Rucker, Mattie Butler, William Butler, and Willa Vaughn. Myrtle G. Lord was instrumental in the creation of the Bradley Academy Museum and Cultural Center. A longtime educator in schools such as Little Hope in Smyrna and Bradley Academy in Murfreesboro, she lived well into her 90s and now has a local library branch named for her in Patterson Community Center. Her home still stands on Hancock Street in Murfreesboro. (Courtesy of Mattie Butler.)

Jerry O. Anderson, son of James L. Butler Sr., was born in Rutherford County and graduated from Central High School. He attended college in Oklahoma and then went on to play professional football with the Cincinnati Bengals and the Tampa Bay Buccaneers in the NFL, as well as the Hamilton Tiger-Cats in the Canadian Football League. On May 27, 1984, he rescued some trapped motorists from floodwaters in Tulsa, Oklahoma. After leaving professional football, he moved back to Murfreesboro with his family. Five years later, on May 27, 1989, he drowned while saving two boys swept away by the rapid current in the Stones River. A *Rescue 911* television show episode was filmed about the incident and his heroic actions. The Jerry Anderson Humanitarian Award was created in his honor and is awarded annually in Rutherford County. He was also awarded the Congressional Medal of Honor for his bravery. (Courtesy of James L. Butler Sr.)

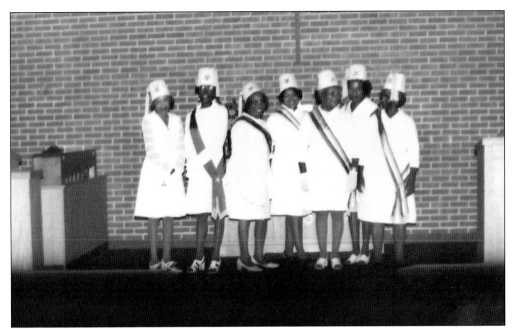

This 1974 photograph is of the Venus Chapter No. 61 Order of the Eastern Stars posed at Key United Methodist Church. This photograph shows members Dolores Williams Butler, Cassie Mae Clark, and Annie Lou Black, among others, as a part of this active community group. Cassie Mae Clark married Pete Clark and lived for many years on Woodbury Road. The Clarks were members of Prosperity Baptist Church in the Dilton community. (Courtesy of James L. Butler Sr.)

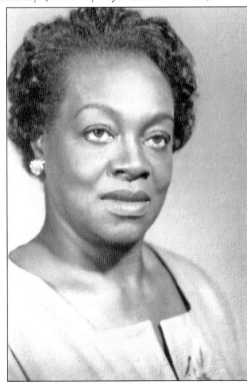

The woman in this old photograph is unidentified. (Courtesy of James L. Butler Sr.)

Tommie Lee and Elodie Alexander Batts are posed here at a Shriner Potentate Ball event in Nashville. Elodie Alexander, Rutherford County native, attended old Gladeview School. She has fond memories of the one-room country school. She recalls that it held grades one through eight and that her principal was Mr. Knight, with teachers Myrtle Lord and Roberta Goodman. She remembers in later days the kitchen being added to the school and Marjorie Vields Beard serving as the cook for the school. Batts went on to become one of the first African American nurses at the local hospital. She recalls a Mrs. Finch and Blossie Rucker Butler preceding her in nursing in the area and having worked with Butler at the Veteran's Hospital. Batts recalls Room 129 as the ward at Rutherford Hospital where all African Americans were assigned. She remembers that African Americans were not hired to work there in the 1940s and that white nurses cared for patients, and no matter the diagnosis, African Americans were placed in the ward. She later was a nurse in African American Dr. William Coopwood's office when he had his office on "The End" in the 1970s. "The End" was on the corner of Sevier and University Streets and was the former site of Turner Hall. This was a social gathering site for clubs and community organizations. Batts also remembers other physicians in town, such as Dr. D. C. Hardin, Dr. J. B. McClellan, Dr. Vernal W. Cambridge, and Dr. James Patterson. Dr. Cambridge, she recalls, was from the islands, spoke with an accent, and was quite handsome. To this day, Elodie Batts still enjoys working, albeit part-time. (Courtesy of Mary Jane Johnson.)

Willie A. McGowan and his wife, Pauline, are pictured at an Improved Benevolent Protective Order of the Elks convention. He at one point held the post of Exalted Ruler of the local Elks group and chair of the Bradley Academy Historical Commission. (Courtesy of Mary Jane Johnson.)

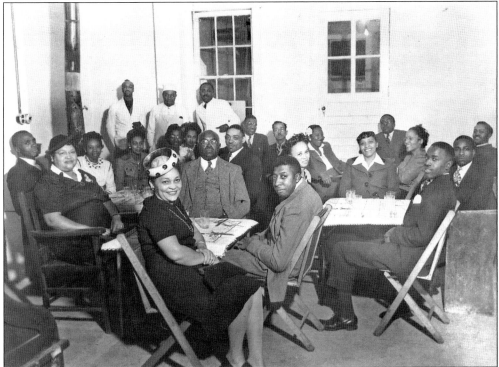

Here is a First Baptist Church dinner event, with L. C. Finch seated far left leaning against the wall. People assembled include Catherine and Tommy Franklin, Georgella Washington, Luther Glanton, Alma Murray, Ruth Smith, Rev. William Donaldson (the First Baptist Church minister), and George Woods. (Courtesy of Houston Overton.)

Wash and Ruby Mae Brown, former members of Key United Methodist Church, are pictured here. Ruby Mae was in the choir, while Wash was a member of the United Methodist Men's Group. Folks of the era recall that he was at one time employed along with Elmo Goodwin at Cohen's Furniture Store, located on the "Mink Slide" in Murfreesboro. The area held several African American businesses from South Maple Street leading to Vine Street on the square. It included Fred Malone Sr.'s barbershop and Joe Nesbitt's barbershop. Dora Rucker recalls a bus driven by Hosea Butler stopping on the "Mink Slide" that one could catch to go to Nashville. The bus was owned by a Mr. Bracey. Preston Scales, founder of Scales and Sons Funeral Home, operated a poolroom there. Clyde Rush had a business there as well. (Courtesy of Thenartis Ellis.)

Ellen Wade, former director of food services for Murfreesboro City Schools, and her husband, educator Aaron D. Wade, former teacher at Locke Elementary are pictured. Wade's father, Aaron Wade Sr., was a member of an African American brass band that played in the area. Other band members included King George Gannaway, Willie Lee Alexander, John Savage, Virgil Officer, Ken Adams, Preston Scales, and Ed Turner. The band was known to travel outside the area for various competitions. Ed Turner, known for his vibrant personality and immaculate dress, was in charge of maintenance at the college. He built Turner Hall, located on the corner of University and Sevier Streets. The hall was a business and social meeting place. Some older residents remember the nickel player piano and the vibrant social scene. Across the street was Miss Vick's restaurant owned by Skip and Vick Taylor, which also had quite the social scene. It is said that Murfreesboro at one time had the Count Basie Orchestra play in the area, as well as West Tennessee native Tina Turner. Residents recall that Turner was hosted in a local home while she appeared for the Murfreesboro date, and Elmo Gaines was the scheduler for the event. (Courtesy of Olivia Woods.)

This photograph shows Lee Overton, father of Houston Overton, joking with former First Baptist Church minister Reverend Donaldson while visiting him and his second wife in California. Clara Donaldson is second from right, with the other gentleman unidentified. (Courtesy of Houston Overton.)

Philon Ellis is pictured here. According to her mother, former Middle Tennessee State University employee Thenartis Ellis, she was in the first class of African American students to integrate Middle Tennessee State University Campus School. She began school there in the first grade. She went on to attend the University of Tennessee at Knoxville. (Courtesy of Thenartis Ellis.)

Terrell Ellis was also in the first class of African American students to integrate Middle Tennessee State University Campus School. He began school there in kindergarten. He went on to serve in the Marine Corps. He is the son of former Middle Tennessee State University employee Thenartis Ellis. (Courtesy of Thenartis Ellis.)

This is a picture of a First Baptist Church event. Dr. James R. Patterson is seated front left with his wife, Buena, seated across the table from him, second from the front. Rev. Grady Donald is standing on the right side behind his wife, Clara, seated first on the right. Others assembled include Alma P. Murray, Zack and Evelyn James, and Willie Alsup. The 1949 "Mid-State Fair News" lists Mrs. J. R. Patterson as a member of the Busy Bee Sewing Club. As an active member of the federated club, she represented the group at a 1940 convention in Chattanooga, Tennessee. The 1949 paper listed other members past and current as Ida Reese, Mary Woods, Gussie Bell, Ella Burris, Armanda Johns, Ethel Garrett, Lucy Rabon, Ethel Walkup, Mary D. Moore, Claudie Strickland, Mrs. E. A. King, Mrs. E. A. Davis, and Nancy Jarrett. An article in the "Mid-State Fair News" states that the group won several awards at the fair as well as gave money to widows, wrote letters to servicemen, and donated to the American Red Cross, among other honorable deeds. (Courtesy of Houston Overton.)

Chester A. Rucker, World War II veteran and Murfreesboro native, did carpentry work and was a barber. He married Dora Robinson, who recalls their first date was going to a movie. They lived for a time on Sevier Street. (Courtesy of Dora Rucker.)

Dora Robinson Rucker is a retired beautician and current-day political activist. Ms. Dora, as she is called, wields political respect and clout. Born on November 11, 1910, she became involved in politics in the 1960s when Robert "Tee-niny" Scales ran for the city council. Rucker was an avid campaigner and registered many voters. Since then, she has been a member of numerous civic and community contributions, including the Order of the Eastern Star, the Rutherford County Election Commission, and the Rutherford County Democratic Women, as well as being an Avon representative for over half a century. She has been a member of First Baptist Church since her early 20s. She even has a road named after her in Rutherford County. (Courtesy of Dora Rucker.)

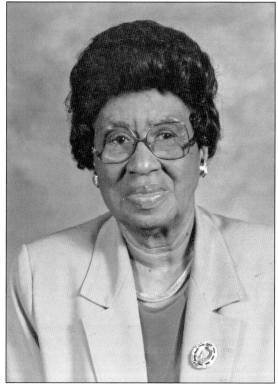

These are choir members of First Baptist Church. They are (from left to right) Dorothy Robinson, Evelyn Lewis, Florence B. Taylor, and H. Bennett. Dorothy Robinson Daniels lived across the street from Key United Methodist Church for many years. (Courtesy of Houston Overton.)

This is a photograph of a young and spry Ernestine Burrus at 17. A 1942 graduate of Holloway High School, she turned 18 years old only days after graduation. Ernestine Burrus Tucker is from a family of entrepreneurs and teachers. A graduate of Bradley Academy and Holloway High, she is a native of Rutherford County. After moving away, she later married serviceman Francis G. Tucker, spending many years in Bronx, New York, and traveling the country. Upon retiring from the American Bank Note Company in New York, she returned to Murfreesboro to build her retirement home on the corner of University and Sevier Streets, the exact spot on which she was raised and her mother was born. She began receiving pictures and articles borrowed from donors to be used by the Center for Historic Preservation at Middle Tennessee State University. She was honored for this work. She is now a member of Emery United Methodist Church. (Courtesy of Ernestine Tucker.)

Local NAACP members Yvette Richardson, Tammy Johnson, Linda Vickers, and Bea McHenry stand in front of the National Association for the Advancement of Colored People building in Baltimore, Maryland. Johnson, a Rutherford County native, was serving as the chair of the National Youth Works Committee for the NAACP at the time, which placed her on its national board of directors. Johnson graduated from Middle Tennessee State University and went on to host her own public affairs show and serve as a news reporter. She has worked in video production and is now an independent filmmaker and chief executive officer of Open Rivers Pictures, based in Atlanta, Georgia. She has created the "My Destiny's Place" children's DVDs and is a published author. Yvette Richardson is the sister of talented pianist, musician, and Rutherford County native William Richardson. William Richardson has played piano and recorded with many famous groups, including the Winans. Tammy Johnson Williams is married to Alvin Williams of Chattanooga. (Courtesy of Mary Jane Johnson.)

Mary Jane Johnson, a longtime resident of Rutherford County, attended Locke Elementary School; however, she recalls having to attend Little Hope School for 16 days and not enjoying the strict teachers and the "country vegetables" served that she did not eat at home. Johnson operated a beauty salon business in the area for over 25 years. She served as a member of the Tennessee IBPOE Daughter of the Elks, Rebecca Carney Temple No. 798, and traveled to several national conventions. She also held membership in a local social club, the Modernistics. She is the mother of Tammy Johnson Williams of Atlanta, Georgia, and Terrence Johnson of Murfreesboro. (Courtesy of Mary Jane Johnson.)

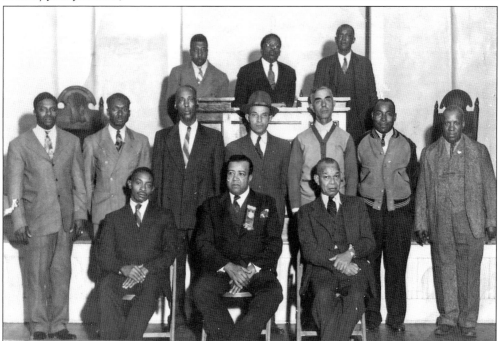

This photograph is identified as the local Page Scott Masonic Lodge at First Baptist Church by Houston Overton. In the first row, far right, is Dr. James R. Patterson. Houston Overton's father, Lee Overton, is standing in the second row fourth from the left. Others identified are Sam Clark, Bill Strickland, Eugene Smith, John Washington, Robert Beatty, George Jones, Alma P. Murray, and Rev. William Donaldson. (Courtesy of Houston Overton.)

Wilma Scales Hancock is honored on her birthday in 1978. Here well-wishers include her husband, Douglas, directly behind her, his sister, and her husband. This was taken in Connecticut, where they lived at the time. Ernestine Tucker is bending on the right. Eventually Wilma and Douglas moved back to Murfreesboro and built a house on Johnson Street. Her brother Robert "Tee-niny" Scales was the first African American to serve on the Murfreesboro City Council in the 1970s, followed by his wife, Mary. The Scales family has a Murfreesboro City Elementary School named in their honor. The family funeral home is still in existence today. (Courtesy of Ernestine Tucker.)

Deborah Elaine Woods, daughter of Olivia ("Stina") and Collier Woods Sr., is posed here with her hands on the shoulders of a young Kelvin Jennings, son of Ramona Jennings, who attended Holloway High. Cornelia Coppage Bender (back left), "Dimple" as she was called, was a longtime active member of Key United Methodist Church. (Courtesy of Olivia Woods.)

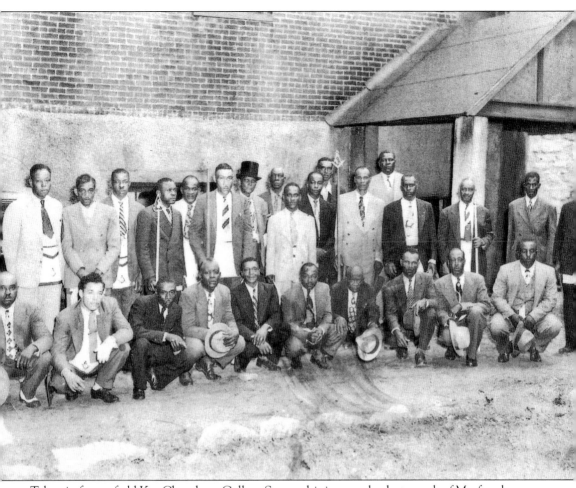

Taken in front of old Key Church on College Street, this is an early photograph of Murfreesboro Lodge No. 12. The lodge is Prince Hall affiliated. Some of the people identified are Preston Scales, Eugene "One Arm" Smith, Obid Strickland, Martin H. Benford, Caleb Smith, ? Rogers, Hamp Swafford, Jim Hellum, Jim Dunston, and Joe Vaughn Sr. Martin H. Benford is noted as the owner of the first African American service station in town. The business was located on Maney Avenue. Known to be a man of great compassion and service, he also owned a coal company and a truck and was known to not only offer credit when needed, but to give a ride as well. Jim Hellum, a native of Lebanon, owned and operated a funeral home in town. His family still has the business in town. Isabell and John S. Killgo also had a funeral home in town. They are seen as advertisers in the 1949 edition of the "Mid-State Fair News." (Courtesy of Houston Overton.)

This is a picture of the current Butler Century Farm. The barn was built by Oscar A. Butler with assistance in a renovation by his son, current owner James L. Butler Sr., upon James's return from military service during World War II. James Butler recalls salvaging lumber from the demolition of an old school site on Main Street with his father to reuse the lumber for the barn renovation. (Courtesy author's collection.)

The Butler Century Farm barn is pictured here. This farm was designated by the Tennessee Department of Agriculture as a family farm that has been in continuous use since 1880. The farm is one of four African American century farms in the state. (Courtesy author's collection)

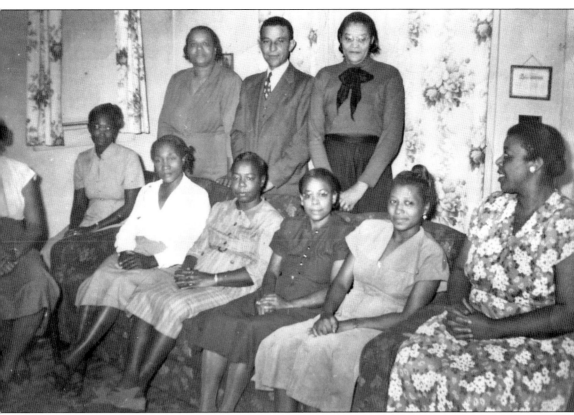

This group assembled is thought to have been members of an Order of the Eastern Star group. Lee Overton (standing) is the father of Houston Overton. Houston remembers his father serving as Worshipful Master of the Page Scott Lodge in town. The following are, from left to right, (seated, first row) two unidentified people, Mrs. James, Mrs. Robert Goodman, Mary Hartful, unidentified, RubyLee Jones Goodman; (standing, second row) Mrs. Tennie Pauline Overton, Lee Overton Sr., and Francis Trimble. Ruby Jones Goodman was an excellent cab driver in town, notes Mattie Butler. (Courtesy of Houston Overton.)

This woman is thought to be a cousin of Dolores Williams Butler. (Courtesy of James L. Butler Sr.)

This June 1966 picture shows Deputy Sheriff L. D. McKnight posed in front of a car. (Courtesy of James L. Butler Sr.)

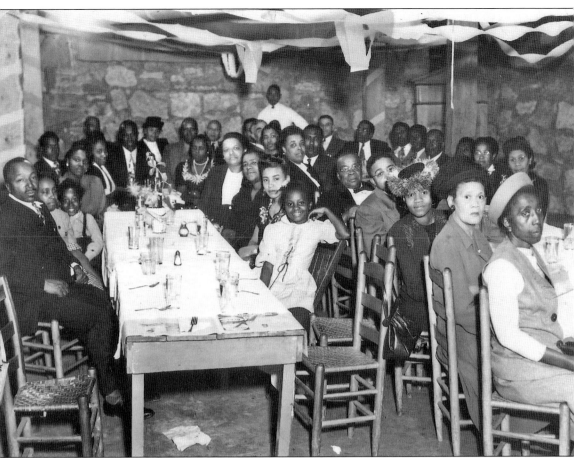

A group is assembled for dinner in the basement of the old First Baptist Church on Spring and East Sevier Streets. Reverend Magwood is remembered as the minister. Obid Strickland is seated at front on the left. William "Sneak" Butler is seated fourth from front on the right in the glasses, with wife, Mattie, in a hat beside him. This event is identified as being in the original church location prior to the church congregation splitting. (Courtesy of Houston Overton.)

Pictured is an unidentified woman thought to be a relative of Dolores Williams. (Courtesy of James L. Butler Sr.)

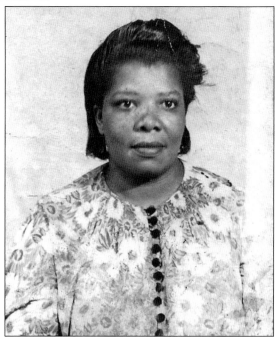

This is an unidentified woman. (Courtesy of James L. Butler Sr.)

This is a photograph of Willie Bell Wright Dunn, mother of Andrew Dunn. She was a trained nurse who delivered babies in Rutherford County. According to her daughter-in-law, Ann, she delivered them as far away as Gatlinburg and Nashville. Close friends to her were Mae Sue Alexander and her daughter Elodie Alexander Batts. Born in 1900, Dunn, who was adopted, was said to have taken the name of the family that raised her. (Courtesy of Ann Dunn.)

This is Sam Dunn, the father of Rutherford County educator Andrew Dunn. He was also the husband of midwife Willie Belle Dunn. (Courtesy of Ann Dunn.)

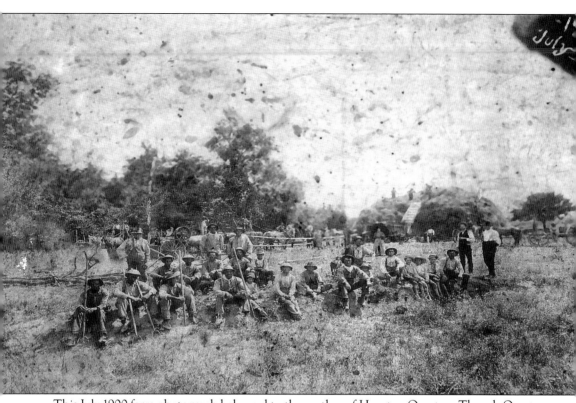

This July 1900 farm photograph belonged to the mother of Houston Overton. Though Overton is uncertain as to where it was taken, it seems to be of African American farm workers. (Courtesy of Houston Overton.)

This is an unidentified woman posed in a chair outside in front of a house. (Courtesy of James L. Butler Sr.)

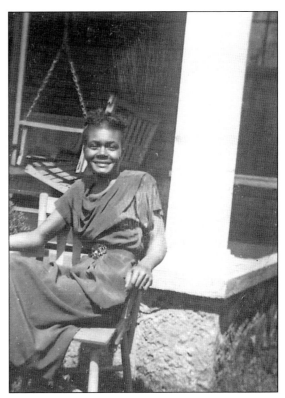

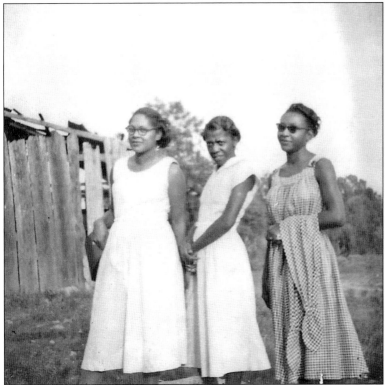

A young Rose Williams (center) poses with two other young ladies for a photograph in the country. Rose Williams was a lifelong active member of Key United Methodist Church, where she was active in the Communion Stewards. (Courtesy of James L. Butler Sr.)

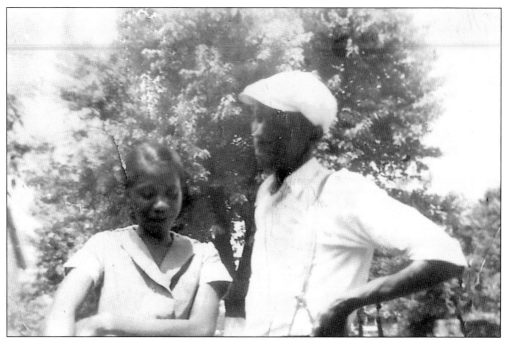

Rose Williams is shown here with a gentleman named John. Rose Williams, a longtime member of Key United Methodist Church who grew up on Sevier Street, was one of several children of Rose Overall, who was also a member of the church. Rose Williams McKnight was a longtime worker for the Waller family of Murfreesboro. (Courtesy of James L. Butler Sr.)

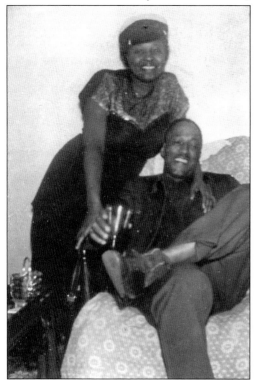

This unidentified couple is posed with the gentleman holding a drink. (Courtesy of James L. Butler Sr.)

The unidentified girl in a scarf is thought to be a cousin of Dolores Williams Butler. (Courtesy of James L. Butler Sr.)

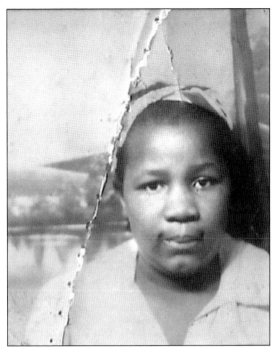

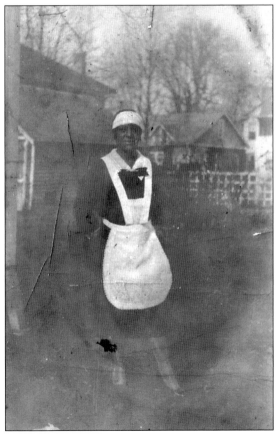

This is an unidentified woman in a maid's uniform. (Courtesy of James L. Butler Sr.)

An elderly gentleman in a hat wearing a necktie is posed here. (Courtesy of James L. Butler Sr.)

This is a relative of Gracie King Jordan of Rutherford County. Gracie King was pictured in the 1949 edition of the "Mid-State Colored Fair News" as a hostess. She grew up on Highland Street in Murfreesboro and lives there, in her mother's home, today. She tells a story of hopping on a bus and traveling to Lebanon, Tennessee, with friends Dolores ("Lo Lo") Williams and Dorothy Robinson. (Courtesy of James L. Butler Sr.)

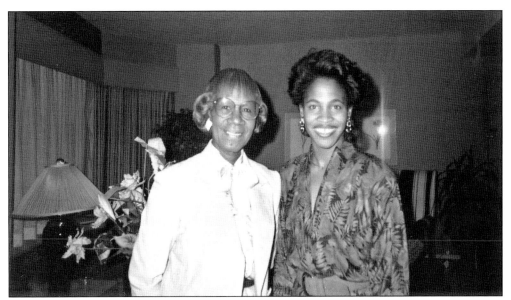

Devora Butler (right), a Rutherford County native, is pictured here with the Honorable Shirley Chisholm in the early 1990s in Seattle, Washington. Butler was serving in her second term as national third vice chair of Chisholm's organization, the National Political Congress of Black Women, founded in 1984. Butler worked to charter a local chapter in Seattle while working as a congressional assistant to the Seattle-area congressman. Chisholm was invited to address the local organization. Butler is a 1983 graduate of Oakland High School in Murfreesboro. She went on to pledge Zeta Delta Chapter, Alpha Kappa Alpha Sorority, Inc., at the University of Tennessee at Knoxville in 1984 and become active in Student Government Association and in the Pan-Hellenic organization. (Courtesy author's collection)

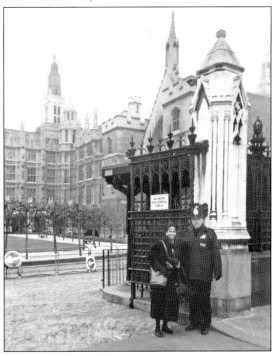

Devora Butler is pictured here in front of the Palace of Westminster, where she worked in London, England, in the mid-1990s. While attending the University of London, she worked for the first black female elected to the British Parliament. She later graduated with a master of arts in education from the University of London, Institute of Education. She graduated from the University of Tennessee at Knoxville with an undergraduate degree in political science and a minor in business. (Courtesy author's collection.)

This is a picture of an unidentified man in his undershirt outside by his clothesline. (Courtesy of James L. Butler Sr.)

An unidentified woman is reading a paper in a chair underneath a lamp. (Courtesy of James L. Butler Sr.)

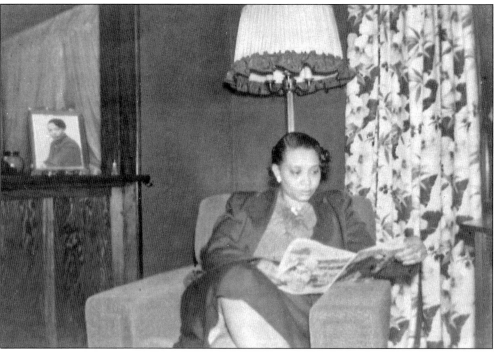

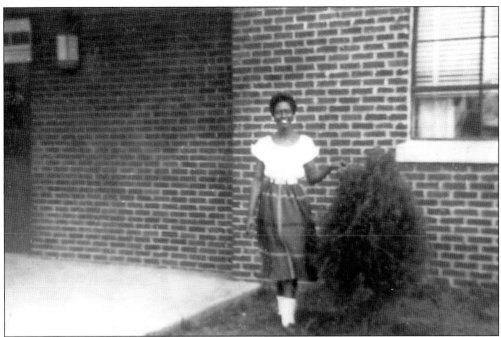

Rutherford County native
Gwendolyn McKnight
is posed by a shrub for a
photograph. (Courtesy
of James L. Butler Sr.)

This is a fashionable
hairstyle on an unidentified
young woman. (Courtesy
of James L. Butler Sr.)

This is a much older Joe Vaughn Jr. (left) and Fred Beneby. The son of Cora Vaughn (educator and longtime member of Key United Methodist Church) and Joseph Vaughn Sr., Dr. Joseph E. Vaughn Jr. was a graduate of Holloway High School and captain of the winning 1941 Bears football team. He went on to graduate from Fisk University in Nashville, as well as Columbia University in New York. He is seen here with Fred Beneby of Florida at the Middle Tennessee State University Arbors to Bricks Banquet in 1994. (Courtesy of Ernestine Tucker.)

BIBLIOGRAPHY

Arnette, C. B. *From Mink Slide to Main Street.* Murfreesboro, TN: B&E Graphics, 1992.

The Goodspeed Histories of Maury, Williamson, Rutherford, Wilson, Bedford and Marshall Counties of Tennessee. Columbia, TN: Woodward and Stinson Printing Company, 1971.

Henderson, C. C. *The Story of Murfreesboro.* Franklin, TN: The Franklin Publishing Company, 1977.

A History of Rutherford County Schools to 1972, Volume 1. Murfreesboro, TN: Rutherford County Historical Society, 1986.

Hughes, Melvin E. Sr., *A History of Rutherford County's African American Community.* Murfreesboro, TN: Allen Chapel A.M.E. Church Publishers, 1996.

Occupied Murfreesboro: Historic Photographs from the Civil War Era. Murfreesboro, TN: Center for Historic Preservation, Middle Tennessee State University, 2004.

http://users.bestweb.net/%7Erg/lynchings/Tennessee%20Lynchings.htm

Discover Thousands of Local History Books
Featuring Millions of Vintage Images

Arcadia Publishing, the leading local history publisher in the United States, is committed to making history accessible and meaningful through publishing books that celebrate and preserve the heritage of America's people and places.

Find more books like this at
www.arcadiapublishing.com

Search for your hometown history, your old stomping grounds, and even your favorite sports team.

Consistent with our mission to preserve history on a local level, this book was printed in South Carolina on American-made paper and manufactured entirely in the United States. Products carrying the accredited Forest Stewardship Council (FSC) label are printed on 100 percent FSC-certified paper.

MADE IN THE USA